Magnificent Dreams

Magnificent Dreams

BURNE-JONES AND THE LATE VICTORIANS

Frances Spalding

E. P. Dutton · New York

Acknowledgements

A book of this kind owes much to the scholarship that first reawoke interest in the period. My debt to these authors is I hope made apparent in the bibliography to be found on page 6. I am grateful to various museums and art galleries for making accessible to me works not on display and I would like particularly to thank the staff of Oldham Art Gallery; the Watts Gallery, Compton; Wightwick Manor, Wolverhampton; Guildhall Art Gallery, London; Laing Art Gallery, Newcastle; South London Art Gallery; Ferens Art Gallery, Hull; City Art Gallery and Museum, Birmingham; Manchester City Art Gallery; Walker Art Gallery, Liverpool, and the Tate Gallery, London. Finally a special word of gratitude to Dr Deborah Cherry for her advice and for reading the manuscript, and to my husband, Julian, for his stimulating disencouragement.

For my mother

Phaidon Press Limited, Littlegate House,
St Ebbe's Street, Oxford

First published 1978
Published in the United States of America by E. P.
Dutton, New York.
© 1978 Phaidon Press Limited
All rights reserved

ISBN 0 7148 1827 5 (cased)
ISBN 0 7148 1909 3 (paperback)
Library of Congress Catalog Card Number: 78-55004

Printed in Great Britain by Waterlow (Dunstable) Ltd

List of Plates

Select Bibliography

Unless otherwise stated all books were published in London.

ARTS COUNCIL of Great Britain. *Burne-Jones*. Catalogue by John Christian of exhibition at the Hayward Gallery 1976

BALDRY, A. Lys. *Albert Moore: His Life and Works*. G. Bell & Sons 1892

BALDRY, A. Lys. 'J. W. Waterhouse and his Works.' *Studio*, January 1895

BARRINGTON, Mrs Russell. *G. F. Watts. Reminiscences*. George Allen 1905

BARRINGTON, Mrs Russell. *The Life, Letters and Work of Frederic Leighton*. 2 vols, George Allen 1906

BATE, Percy. *The English Pre-Raphaelite Painters: Their Associates and Successors*. G. Bell & Sons 1899

BELL, Quentin. *Victorian Artists*. Routledge & Kegan Paul 1967

BLUNT, Wilfrid. *England's Michelangelo: A Biography of George Frederic Watts, O.M., R.A.* Hamish Hamilton 1975

BOASE, T. S. R. *English Art 1800–1870*. Oxford University Press 1959

BUCKLEY, Jerome Hamilton. *The Victorian Temper. A Study in Literary Culture*. Allen & Unwin 1952

BURNE-JONES, Georgiana. *Memorials of Edward Burne-Jones*. 2 vols, Macmillan 1904

CARR, J. Comyns. *Some Eminent Victorians*. Duckworth 1908

CHAPMAN, Ronald. *The Laurel and the Thorn*. Chapman 1945

CHESNEAU, Ernest. *The English School of Painting*. Cassel 1885

DAFFORNE, James. 'The Works of Edward J. Poynter, R.A.' *Art Journal* 1877

DOUGHTY, Oswald. *A Victorian Romantic: Dante Gabriel Rossetti*. Oxford University Press (1949) 1960

DOUGHTY, Oswald & J. R. Wahl (eds). *Letters of Dante Gabriel Rossetti*. 4 vols, Oxford: Clarendon Press 1965 & 1967

FITZGERALD, Penelope. *Edward Burne-Jones: A Biography*. Michael Joseph 1975

FREDEMAN, William. *Pre-Raphaelitism. A Bibliocritical Study*. Cambridge, Mass.: Harvard University Press 1965

GAUNT, William. *The Pre-Raphaelite Tragedy*. Jonathan Cape 1942

GAUNT, William. *The Aesthetic Adventure*. Jonathan Cape 1945

GAUNT, William. *Victorian Olympus*. Jonathan Cape 1952

GRYLLS, Rosalie Glynn. *Portrait of Rossetti*. Macdonald 1964

HAMILTON, Walter. *The Aesthetic Movement in England*. Reeves & Turner 1882

HARRISON, Martin & Bill Waters. *Burne-Jones*. Barrie & Jenkins 1973

HILTON, Timothy. *The Pre-Raphaelites*. Thames & Hudson 1970

HUNT, John Dixon. *The Pre-Raphaelite Imagination 1848–1900*. Routledge & Kegan Paul 1968

HUNT, William Holman. *Pre-Raphaelitism and the Pre-Raphaelite Brotherhood*. 2 vols, Macmillan 1905–6

HUTCHINSON, Sidney C. *The History of the Royal Academy 1768–1968*. Chapman & Hall 1968

IRONSIDE, Robin. 'Burne-Jones and Gustave Moreau.' *Horizon* 1940

IRONSIDE, Robin & John Gere. *Pre-Raphaelite Painters*. Phaidon 1948

LAING ART GALLERY, Newcastle-upon-Tyne. *Albert Moore and his Contemporaries*. Catalogue by Richard Green of exhibition held 1972

MAAS, Jeremy. *Victorian Painters*. Barrie & Jenkins 1969

MARILLIER, H. C. *Dante Gabriel Rossetti: An Illustrated Memorial of his Art and Life*. G. Bell & Sons 1899

MONKHOUSE, Cosmo. 'E. J. Poynter, P.R.A.' *Art Journal*. Easter Annual 1897

MUTHER, Richard. *The History of Modern Painting*. Vol III, Henry & Co 1896

NICOLL, John. *The Pre-Raphaelites*. Studio Vista 1970

NICOLL, John. *Dante Gabriel Rossetti*. Studio Vista 1975

ORMOND, Leonée & Richard. *Lord Leighton*. Yale University Press 1975

PENNELL, E. R. & J. *The Life of James McNeill Whistler*. Heinemann 1908

REYNOLDS, Graham. *Victorian Painting*. Studio Vista 1966

ROBERTSON, Graham. *Time Was*. Hamish Hamilton 1931

ROSSETTI, William M. *Dante Gabriel Rossetti: His Family Letters with a Memoir*. Ellis & Elvey 1895

SKETCHLEY, R. E. D. 'The Art of J. W. Waterhouse.' *Art Journal* Christmas Number 1910

SPENCER, Robin. *The Aesthetic Movement: Theory and Practice*. Studio Vista 1972

SUTTON, Denys. *Nocturne: The Art of James McNeill Whistler*. Country Life 1963

SWANSON, Vern G. *Sir Lawrence Alma-Tadema*. Ash & Grant 1976

WATTS, Mary S. *George Frederic Watts*. 3 vols, Macmillan 1912

WHITECHAPEL ART GALLERY. *G. F. Watts: A Nineteenth Century Phenomenon*. Catalogue by Chris Mullen of exhibition held in 1974

WOOD, Christopher. *The Dictionary of Victorian Painters*. Antique Collectors Club 1971

Burne-Jones and the late Victorians

On May Day 1877 the established London art world was startled, not by a socialist revolt, but by the bright new creation of a moneyed and cultured élite. For on that day the Grosvenor Gallery opened its doors to the public, bringing to a climax the elaborate publicity campaign devised by the gallery's proprietor, Sir Coutts Lindsay. During the previous two months, leading newspapers and periodicals had printed announcements, carefully worded to suggest that the gallery would challenge the supremacy of the Royal Academy, whose annual summer exhibitions determined the success or failure of an artist's career. The *Art Journal* declared that two well-known artists (unnamed) would exhibit, who, in recent years, had 'kept aloof' from the Academy. It was added that the conditions under which the work would be exhibited would be especially sympathetic to subtle colouring and sensitive brushwork. Interest was enhanced by the exclusive inauguration dinner held in the restaurant beneath the gallery two days before the public opening. To this came the Prince and Princess of Wales, together with all that London held of social and artistic distinction. Many days had been spent establishing the correct order of seating, the nobility being very carefully placed in strict order of precedence. Like a complex theatrical performance, the stage had been set, a select group of actors gathered and the public stirred with the expectation that an explosion of artistic talent was about to occur, such as had not been seen in London for many years.

The gallery had been built on the site of three houses in New Bond Street. In an age that had been guided by Ruskin to admire the Gothic for nationalistic and pietistic reasons, the Grosvenor Gallery was flagrantly Renaissance and notably pagan in inspiration. It had cost Sir Coutts £150,000 in all, no expense having been spared to obtain the required sumptuousness. The architect, W. T. Sams, had successfully incorporated into the façade a Palladian doorway, which had been salvaged from the church of Santa Lucia in Venice during demolition. Once inside, the visitor passed through the vestibule flanked by green Genoa marble columns before ascending a fifteen foot wide staircase which led to the picture galleries on the first floor. Immediately on entering the turnstile, the visitor to the inaugural exhibition was met by a large sculpture of Cleopatra by Massini on the one hand and by Whistler's portrait of Carlyle (Plate 2) on the other, an apt confrontation, for it was out of the union of the sensuous with the historical that Victorian classicism was born. It was, however, not until the visitor had entered the principal gallery that the full impact of the exhibition was revealed.

Graham Robertson, the painter, has left us his impression: 'I can well remember the wonder and delight of my first visit. One wall

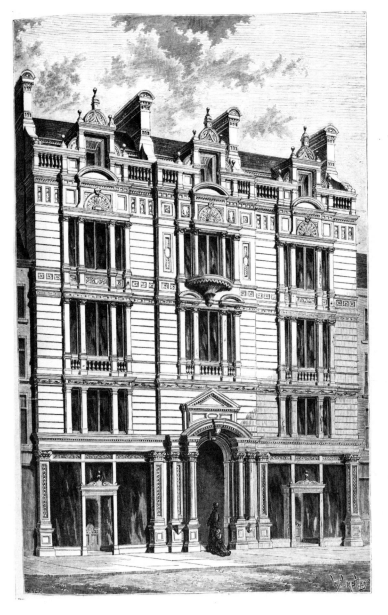

1. The Façade of the Grosvenor Gallery. Illustration in the *Builder*, 5 May 1877

was iridescent with the plumage of Burne-Jones's angels, one mysteriously blue with Whistler's nocturnes, one deeply glowing with the great figures of Watts, one softly radiant with the faint, flower-tinted harmonies of Albert Moore.' Not only were the pictures themselves radiant, but so too was the setting: the walls were covered with a rich, red silk damask costing £1,000, and below this was a dado of dark green velvet; the ceiling had been painted a deep blue and decorated with various phases of the moon and stars by Whistler and, beneath, a frieze, designed by Sir Coutts himself, hid an ingenious modern method of air-conditioning. The lily was, of course, gilded, notably the Ionic pilasters, which had been salvaged from the foyer of the old Italian Opera House in Paris and placed at intervals around the walls. Nor did Sir Coutts's concern for elaborate decoration end there: the room was furnished with pottery, plants, oriental rugs, console tables and delicate Italian chairs which could be placed by the spectator in front of whichever painting he wished to contemplate.

The extravagance of the décor was overwhelming. The *Athenaeum* critic pointed out that the brilliant colours detracted from the paintings themselves. Ruskin severely criticized the red silk wall-covering and as a result it was changed the following year to one of a more restrained green. Agnes D. Atkinson, writing in the *Portfolio*, was, however, one of the critics deeply impressed with Sir Coutts's achievement. 'This is no public picture exhibition,' she wrote, 'but rather a patrician's private gallery shown by courtesy of its owner.' Sir Coutts, it seems, was concerned to promote not only art, but also a fashionable life-style in

2. James McNeill Whistler (1834–1903): *Arrangement in Grey and Black No 2: Thomas Carlyle*. 1872–3. Canvas, 171.2 × 143.5 cm. (67$\frac{3}{8}$ × 56$\frac{1}{2}$ in.) Glasgow City Art Gallery

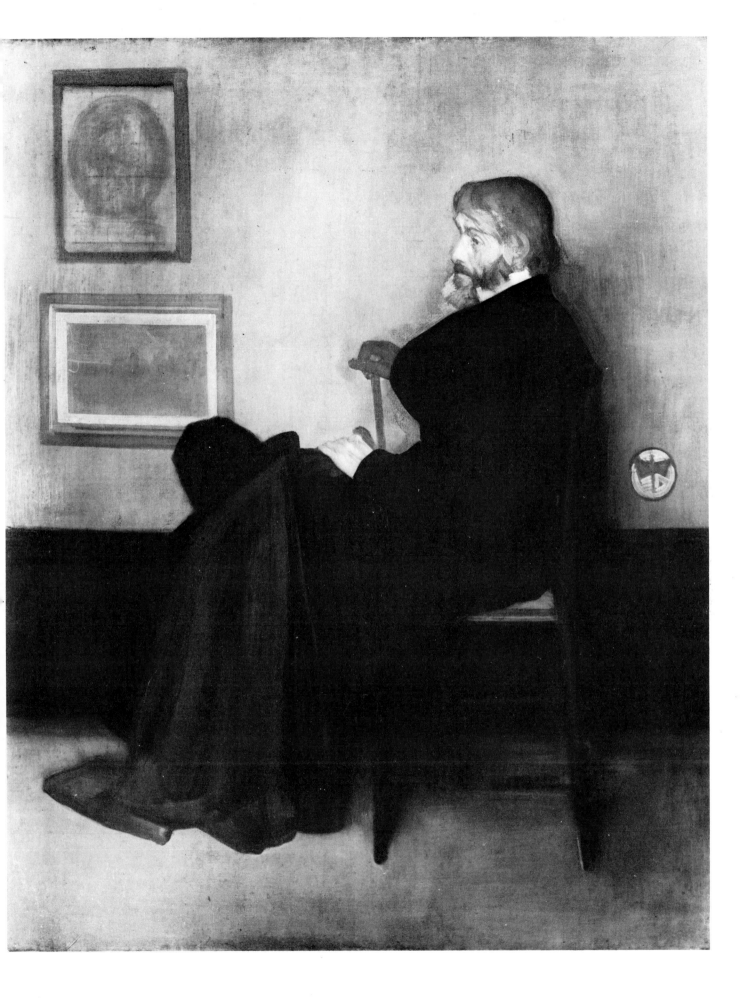

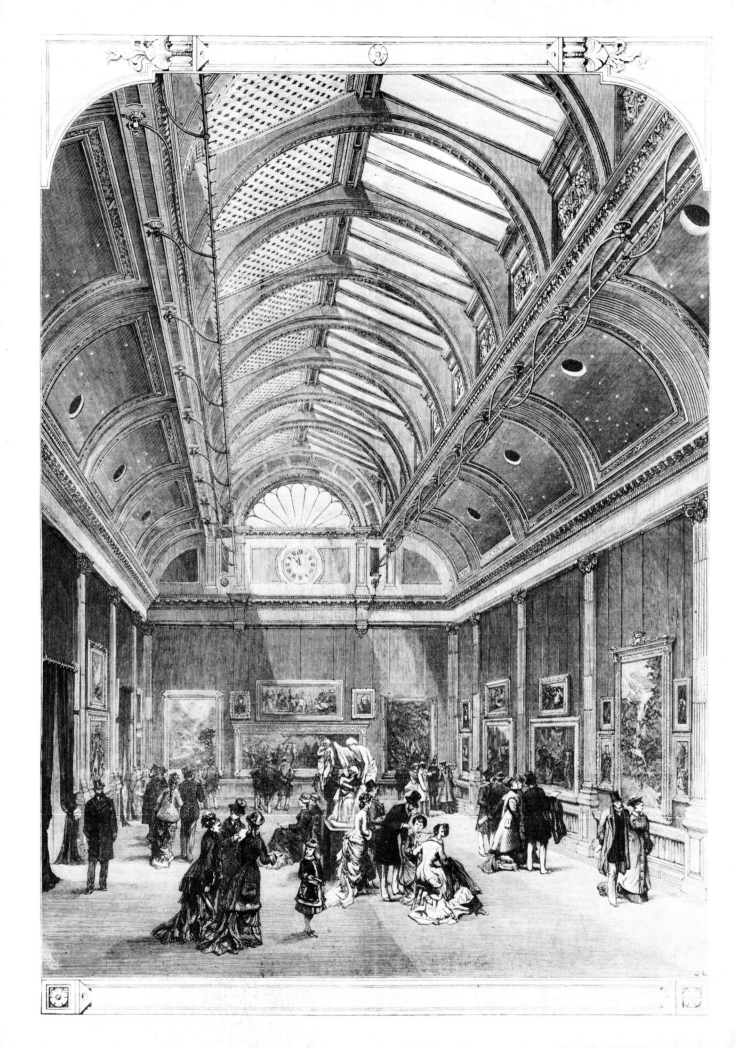

which art was the most important ingredient.

Housed within this elaborate piece of interior decoration was an extraordinary range of art. Paintings and sculpture by Royal Academicians mingled with the work of foreign artists as well as the amateur efforts of Sir Coutts's artistic friends. Holman Hunt upheld the Pre-Raphaelite love of detail and brilliant colour, whilst James Tissot, the Frenchman who had fled to England during the Paris Commune of 1871, astonished the public with his clever representations of social scenes, often dependent for their effect on a moment of psychological tension. His popularity was closely followed by that of Ferdinand Heilbuth, whose anecdotal paintings recreated the mood of Watteau in nineteenth-century terms. Heilbuth's sweetness contrasted with the sombre vision of Alphonse Legros, with the closely observed Italian landscapes by Giovanni Costa and George Howard, and the fantastic imagination found in the fairy themes by Richard (Dicky) Doyle. But the main attraction was the work of Burne-Jones and Whistler, the two notable outsiders, and that of G. F. Watts and Albert Moore. Each of these four artists had a distinctly individual style. Burne-Jones and Watts were allotted opposing end walls of the main gallery, and the works of Whistler and Moore were hung in two separate groups. Despite this, the paintings of these four artists enhanced each other, creating a unity of mood, a pervasive dream-like atmosphere that was new in Victorian art.

Of the paintings by George Frederic Watts, the largest and most impressive was his allegory, *Love and Death* (Plate 9). It presents Death as a tall, shrouded figure with one indomitable arm raised, about to enter the House of Life, whilst Love, personified by a

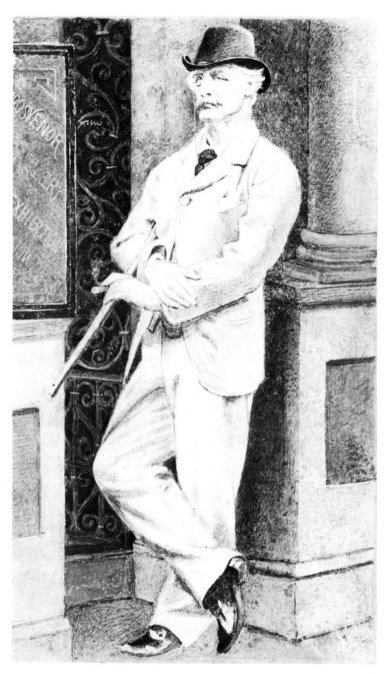

4. *Sir Coutts Lindsay outside the Grosvenor Gallery* by 'Joplin'. 1883. Drawn for *Vanity Fair*. Watercolour, 31.5 × 18.9 cm. (12¾ × 7⅛ in.) London, National Portrait Gallery

3. *The Interior of the Grosvenor Gallery*. Illustration in the *Illustrated London News*, Vol. LXXX, 1877

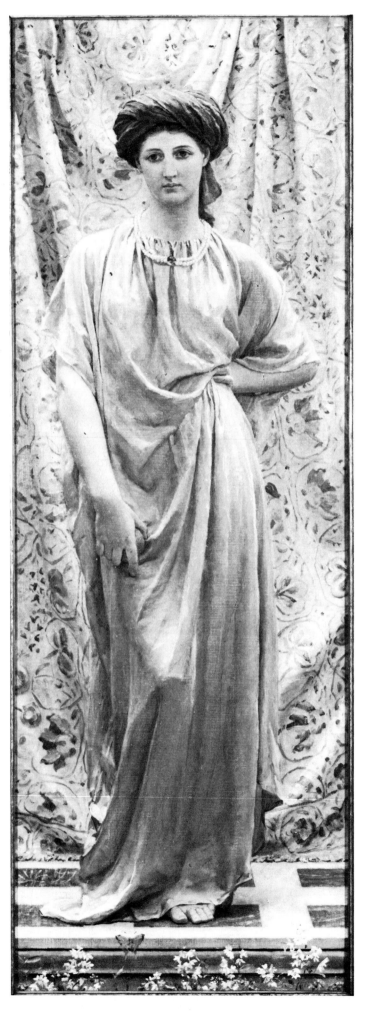

winged cupid, attempts in vain to halt her entry. The idea had come to Watts whilst he was painting the portrait of the Marquis of Lothian, a handsome, intelligent man, afflicted with consumption, who visibly weakened day by day despite all his wife's loving efforts. *Love and Death* was recognized at the Grosvenor by the critic of the *Athenaeum* as being 'among the noblest works of our time', even though it was exhibited unfinished. Watts painted eight versions of this subject and it is one of the most successful of his allegories, the gestures being well suited to the idea expressed. It later received unexpected praise from D. H. Lawrence for its 'blurred idea that Death is shrouded, but a dark embracing mother, who stoops over us, and frightens us because we are children.'

If *Love and Death* was intended to evoke moral thought, other paintings included in this first Grosvenor Gallery exhibition were primarily concerned with aesthetics, with the harmonious balancing and ordering of our visual sensations. The work of Albert Moore was a notable example; his *Sapphires* (Plate 5) presents a single standing female figure whose only purpose is to display her deep blue turban, which gives the picture its title, and whilst doing so to adopt an eminently classical pose. The skill with which Moore balances the deep blue with the orange in her hand and echoes less vivid touches of these two colours across the picture can be compared to the formal awareness found in the four Nocturnes exhibited by Whistler, of which *The Falling Rocket* (Plate 14) is one example. These depend for their effect on the fluid manipulation of a limited number of delicate tones and a few strong notes of colour, combined with the

5. Albert Moore (1841–93): *Sapphires*. Exh. 1877. Canvas, 154.9 × 54.5 cm. (61 × 21½ in.) Birmingham City Museum and Art Gallery

merest suggestion of the forms represented.

Whistler's Nocturnes happened to catch Ruskin's eye when he chanced upon the exhibition during a visit to London to address the Society for the Prevention of Cruelty to Animals, and they aroused his singular command of invective. He wrote of them: 'Sir Coutts Lindsay ought not to have admitted works into the gallery in which the ill-educated conceit of the artist so nearly approached the aspect of wilful imposture. I have seen, and heard, much of Cockney impudence before now; but never expected to hear a coxcomb ask two hundred guineas for flinging a pot of paint in the public's face.' The result was the famous Whistler v. Ruskin trial in which Ruskin upheld the notion of finish and 'truth to nature' against Whistler's fresh way of looking at nature, which seemed to Ruskin, in its emphasis on selection and swiftness of execution, to be a shallow hoax. Whistler won the case, was awarded a farthing damages and was bankrupted by the costs. It nevertheless marked a turning-point in the history of British art, as it pin-pointed a change in artistic philosophy. In contrast to Ruskin's belief that all art should be infused with a moral purpose, Whistler declared that his Nocturnes were 'an arrangement of line, form and colour first', in other words that their value was primarily aesthetic. This attitude characterized the 'art for art's sake' movement which Whistler did much to create, and the increased emphasis on formal means it brought with it had far-reaching influence. Even Burne-Jones's art was closer to Whistler's aesthetic than to that of Ruskin, although in the trial he had unwillingly supported the latter.

Burne-Jones's affiliation to the Grosvenor Gallery guaranteed its success. Indeed, D. G. Rossetti had predicted this in a letter to the gallery's manager, Charles Hallé: 'Your scheme must succeed were it but for one name associated with it – that of Burne-Jones – a name

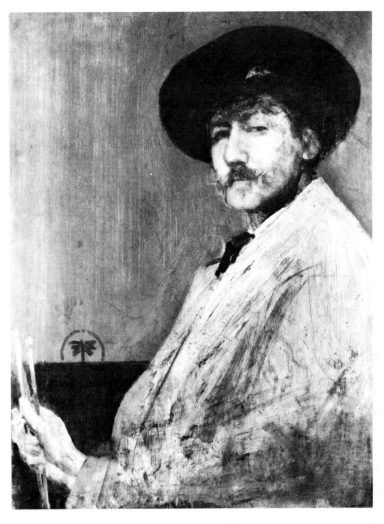

6. James McNeill Whistler (1834–1903): *Arrangement in Grey: Self-Portrait.* 1871–3. Canvas, 74.9 × 53.3 cm. (29½ × 21 in.) Detroit Institute of Arts

13

representing the loveliest art we have.' His opinion was confirmed by G. F. Watts, in a letter to his patron Charles Rickards: 'I expect him [Burne-Jones] to extinguish almost all the painters of the day, in some respects nothing so beautiful has ever been done, so you may prepare yourself for being knocked off your legs.' Yet despite his reputation, his art was not widely known outside a small group of admirers, as he had not exhibited in public (except for two paintings at the Dudley Society) since his resignation from the Old Water-Colour Society in 1870. Thus it was his art which primarily attracted attention when seven thousand people passed the turnstile on the first day of the opening. As Mrs Adams Acton, the wife of a fashionable sculptor, recalled, referring specifically to Burne-Jones, 'everyone arrived with an expression of having come to see something SPECIAL and hoping it wouldn't be very AWFUL.' The public recognition his work now received led Burne-Jones's wife to record in her *Memorials:* 'From this day he belonged to the world in a sense that he had never done before, for his existence became widely known and his name famous.'

By 1877, Burne-Jones had arrived at a mature, distinctive style, dependent for its success on a strange mixture of Gothic spirituality and classical grace, wrapped in the respectability of the Renaissance. Through his study of classical art, he had learnt to simplify and exaggerate his gestures and poses in order to arrive at the utmost expressive power, as seen in his *The Beguiling of Merlin* (Plate 10), the largest of his paintings exhibited. It exuded that melancholy, strange beauty with which

7. George Frederic Watts (1817–1904): *Portrait of Sir Edward Burne-Jones, Bt.* Canvas, 67.7 × 52.1 cm. (25½ × 20½ in.) Birmingham City Museum and Art Gallery. Exhibited at the Grosvenor Gallery in 1877.

8. Sir Edward Burne-Jones (1833–98): *The Fifth and Sixth Day of Creation.* 1875–6. Canvas, each 120.7 × 36.2 cm. (47½ × 14¼ in.) Cambridge, Massachusetts, Fogg Art Museum

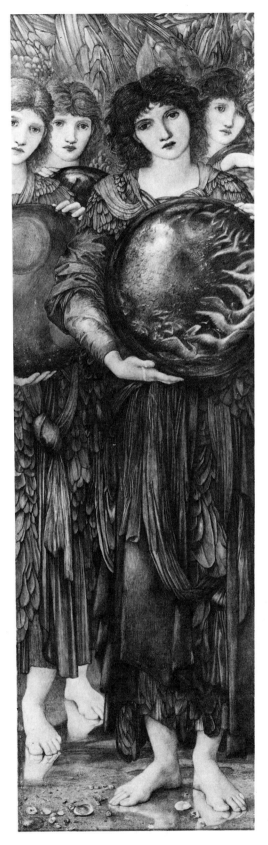
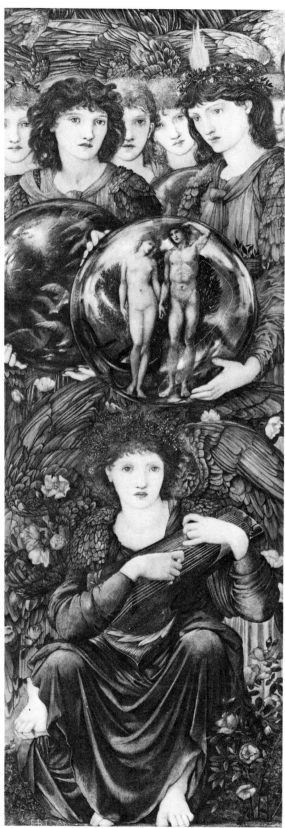

his name became associated. As in the original French medieval tale, Merlin's pupil, Nimuë lulls her master to sleep in a hawthorn tree and, casting one of his own spells upon him, leaves him as powerless as if he were imprisoned in chains of iron. The restless, sinuous curves express the same agitation as that found in Merlin's sidelong glance, whilst the dense clusters of blossom heighten the sense of claustrophobia.

Less anguished were the angels in Burne-Jones's *Days of Creation* (Plate 8), made up of six panels housed in an elaborately carved and lettered Renaissance frame. In each panel an angel holds a sphere in which is mirrored the day by day Creation as described in Genesis, a visual idea that Burne-Jones had taken from a tarot card in the British Museum which was, at that time, ascribed to Mantegna. Each panel is intended to be read separately and a cumulative effect is created as the angel of the first day is included in the background of the second panel, these two in the background of the third, and so on until in the sixth (two being introduced in the final panel) seven angels are crowded into the narrow vertical space. As in the *Beguiling of Merlin*, every area is filled with the variegated colour and texture of wings, draperies, flowers and faces, giving a rich, tapestry-like effect.

The critics on the whole received Burne-Jones enthusiastically. Although *Punch* referred to 'the quaint, the queer, the mystic over-much,' his art well suited the more fastidious taste of Henry James. In his review he declared that the paintings exhibited placed Burne-Jones 'at the head of the English painters of our day'. He continued: 'It is the art of culture, of reflection, of intellectual luxury, of aesthetic refinement, of people who look at the world and at life not directly, as it were, and in all its accidental reality, but in the reflection and ornamental portrait of it furnished by art itself in other manifestations.' Several critics noted the strong literary element in his work and one argued that it illustrated ideas current in contemporary literature, 'the characteristic of which is to dwell always in a world of dreams, to eschew everything that comes too close to merely human and everyday interest, and keeps us in the region of mild, semi-religious mysticism.'

Not only was Burne-Jones hailed as a major artist, he was also seen as the leader of a new group of artists described in the *Aesthetic Review and Art Observer* as 'a school of imaginative painters of the highest type . . . totally distinct in its aims from the main body of contributors to the Royal Academy.' This 'quasi-classical semi-mystical school', as it was elsewhere described, included John Roddam Spencer Stanhope, John Melhuish Strudwick and Walter Crane, all of whom exhibited at the first Grosvenor Gallery exhibition. They were referred to by the *Athenaeum* critic as 'neo-Italians' because their paintings reflected in varying degrees the influence of Florentine Quattrocento art.

Florentine influence was most noticeable in Walter Crane's *Renaissance of Venus* (Plate 16), which, were it not for a certain quaintness and unusual silver colouring, could be described as a pastiche of Botticelli's *Birth of Venus*. If Crane had not seen this masterpiece on his visit to Italy in 1871, he would have known of it from the chromolithograph published by the Arundel Society in 1870. He executed this work at the request of Sir Coutts specifically for the first Grosvenor Gallery exhibition and it accorded well with the gallery's Renaissance spirit. Slight uncertainties in the drawing of the nudes were noted by critics, but this could hardly have been avoided as Crane's wife forbade him to draw from the female nude. Of the three 'neo-Italians', Crane was, perhaps, the most independent talent; he discovered his *métier* in illustration and harnessed medievalism to the

9. George Frederic Watts (1817–1904): *Love and Death*. Canvas, 249 × 116.8 cm. (98 × 46 in.) University of Manchester, Whitworth Art Gallery

10. Sir Edward Burne-Jones (1833–98): *The Beguiling of Merlin*. 1874. Canvas, 186 × 111 cm. (73¼ × 43¾ in.) Port Sunlight, Lady Lever Art Gallery

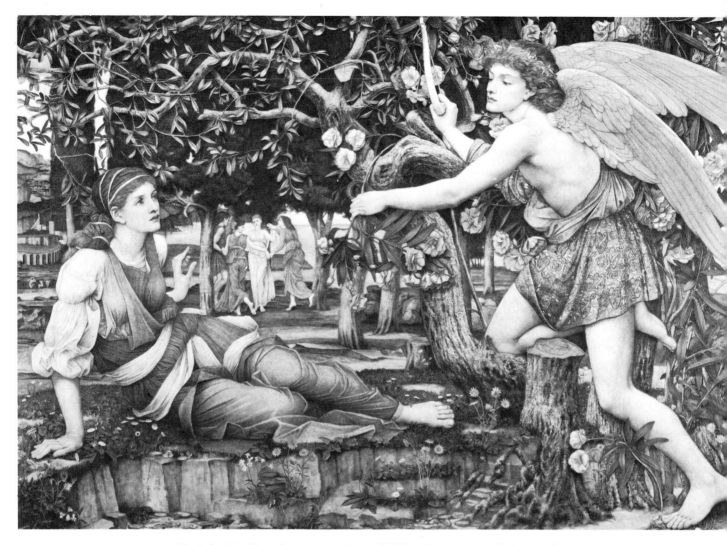

11. John Roddam Spencer Stanhope (1829–1908): *Love and the Maiden*. 1877.
Canvas, 138.5 × 202.5 cm. (54¼ × 79¾ in.) Private Collection, London. (Photograph courtesy of Fine Art Society, London)

socialist cause, giving respectability and grandeur to the new thought through his designs for Trade Union banners and popular woodcuts.

Spencer Stanhope and Strudwick were similarly indebted to the two-fold inspiration of the study of Italian art and admiration for the work of Burne-Jones. Stanhope's career paralleled that of the master in that he too began under the dominating influence of Rossetti, received encouragement from G. F. Watts and developed a veneration for Florentine art. Although he is generally regarded as a follower of Burne-Jones, the latter greatly

admired Stanhope's use of colour and regretted that this talent was not combined with more stringent draughtsmanship. Strudwick studied for a period in both Stanhope's and Burne-Jones's studios and was indebted to the latter for his style and subject-matter. His tendency to heighten Burne-Jones's mannerisms led to a love of detailed architectural

12. John Melhuish Strudwick (1849–1935): *Acrasia*. About 1888. Oil with gold on canvas, 71.1 × 57.1 cm. (28 × 22½ in.) Private Collection, Germany. (Photograph courtesy of Julian Hartnoll)

18

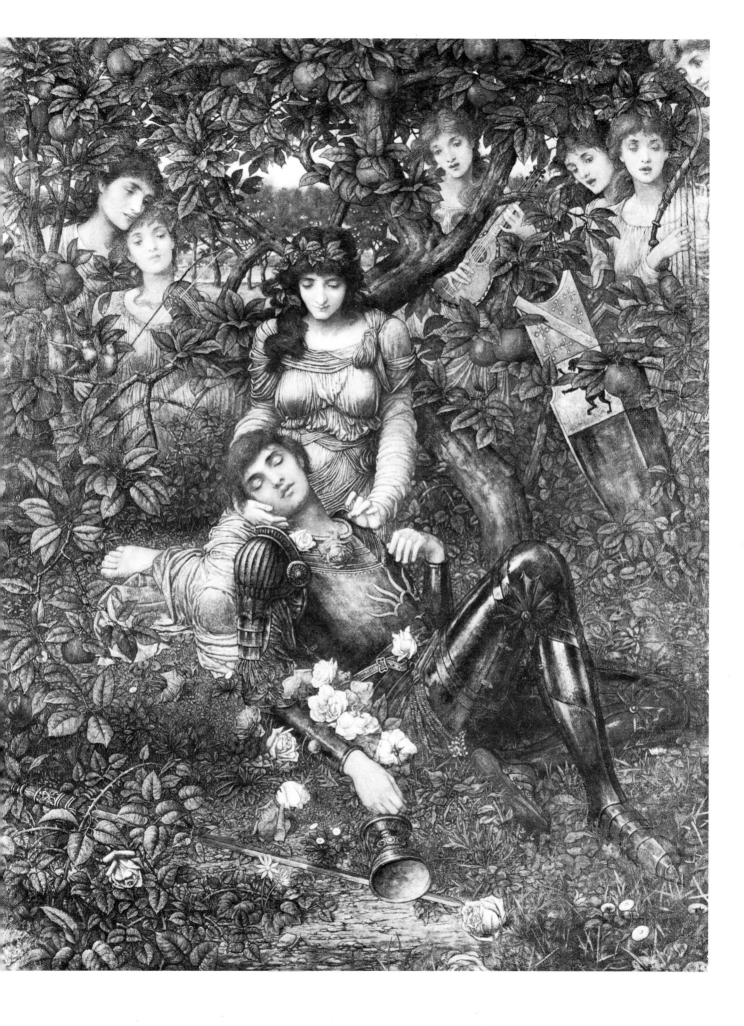

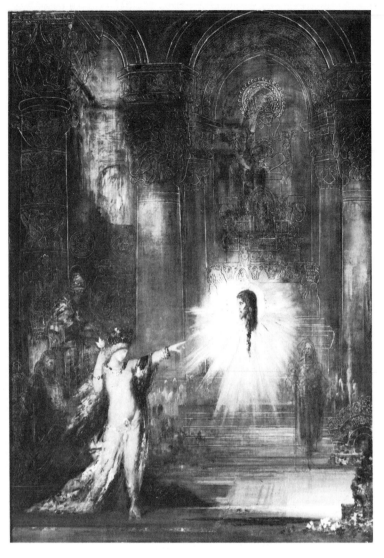

settings and to an intense profusion of flowers, fruit and foliage that threaten to engulf the figures. Added to this, his emphatic linearity earned him the reputation of being a Victorian Mantegna.

Two other factors indirectly enhanced Burne-Jones's reputation during 1887. The first Grosvenor Gallery exhibition included Gustave Moreau's large watercolour *L'Apparition* (Plate 13). As this had been shown at the Paris Salon of the previous year, its appearance at the Grosvenor demonstrated that the new British style was not an insular phenomenon; Moreau's paintings were as exotic, jewel-like and visionary as Burne-Jones's. Also in 1877, a painting by one of Burne-Jones's assistants, T. M. Rooke, was bought from the Royal Academy exhibition by the Chantrey Bequest, a sign of official recognition. As with Strudwick's *Love's Music* (present whereabouts unknown) exhibited at the Grosvenor this year, Rooke's *Story of Ruth* (Plate 15) followed Burne-Jones's frequent use of separate scenes housed within a single frame to expand the narrative of the tale. More restrained and less imaginative than Burne-Jones's paintings, it is nevertheless executed with delicate precision and a sense of the emotional tenor of the story. The *Examiner* critic said of it: 'We could not wish for a more careful arrangement of the chosen tints or a more skilful disposition of the figures in their space.'

Despite the success of Burne-Jones and his followers at the Grosvenor Gallery, one critic was only too grateful to turn from Burne-Jones's work to that of Alma-Tadema. He felt as if he had 'parted from an invalid and passed

13. Gustave Moreau (1826–98): *L'Apparition*. 1876. Watercolour, 105 × 72 cm. (41¾ × 28⅜ in.) Paris, Louvre, Cabinet des Dessins

14. James McNeill Whistler (1834–1903): *Nocturne in Black and Gold: The Falling Rocket*. About 1874. Oil on wood, 60.4 × 46.6 cm. (23¾ × 18⅜ in.) Detroit Institute of Arts

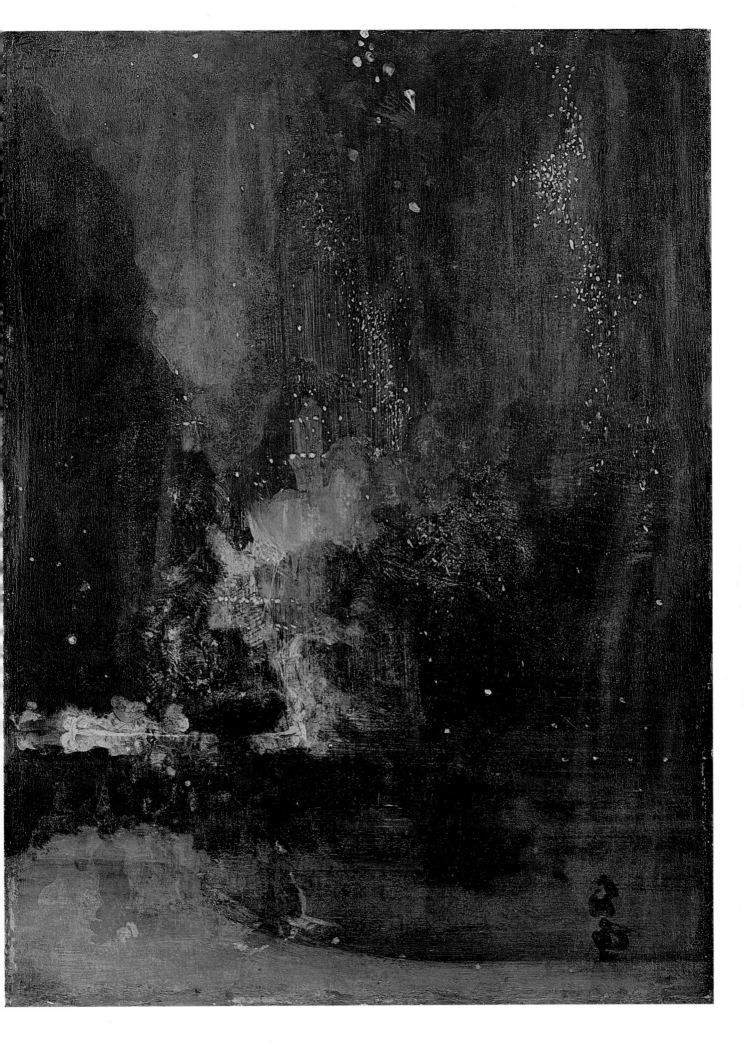

into the company of a person in perfect health'. Burne-Jones's melancholy had no place in the untroubled world of Alma-Tadema, who had already earned himself considerable success at the Royal Academy with his reconstructions of scenes from ancient Greece and Rome. *Pheidias and the Frieze of the Parthenon, Athens* (Plate 19), exhibited at the Grosvenor Gallery this year, was a *tour de force*, particularly as regards his handling of the various light sources including that which comes up from below the scaffolding on which the spectators stand. The brightly coloured frieze, although archaeologically accurate, aroused discussion in the press as to its correctness. The subject, which celebrates the esteem and honour in which Pheidias and his art were held, was in fact a reflection of the social position which Victorian artists, such as Alma-Tadema, hoped themselves to enjoy.

Alma-Tadema enjoyed a good relationship with the Grosvenor Gallery although he remained a strong supporter of the Royal Academy. Such balanced allegiance was not easy to maintain, as the chief motivation behind the founding of the gallery was dissatisfaction with the Royal Academy. Sir Coutts had earlier expressed discontent with the running of the Academy in answer to the Royal Committee appointed in 1863 to investigate the practices of this institution. Ruskin, Holman Hunt, the critic Tom Taylor, G. F. Watts and others drew attention to the exclusiveness of the Academy and its failure to support young artists, but the report had little effect and discontent grew. The idea for an alternative exhibition venue had first been mooted in 1875, when the painter, Charles Hallé, son of the distinguished pianist, was staying with Sir Coutts and his wife at their house at Balcarres in Fife. At first Sir Coutts had offered to guarantee a hundred pounds a year towards the rent of a gallery, but when no suitable rooms could be found, he had decided

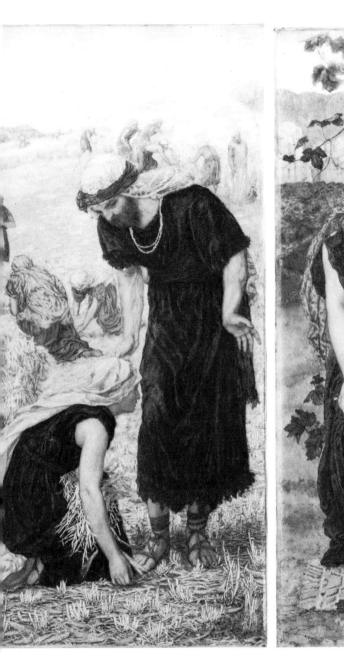

15. Thomas Matthew Rooke (1842–1942): *The Story of Ruth*. 1876–7.
Canvas, each 66 × 39.4 cm. (26 × 15½ in.) London, Tate Gallery

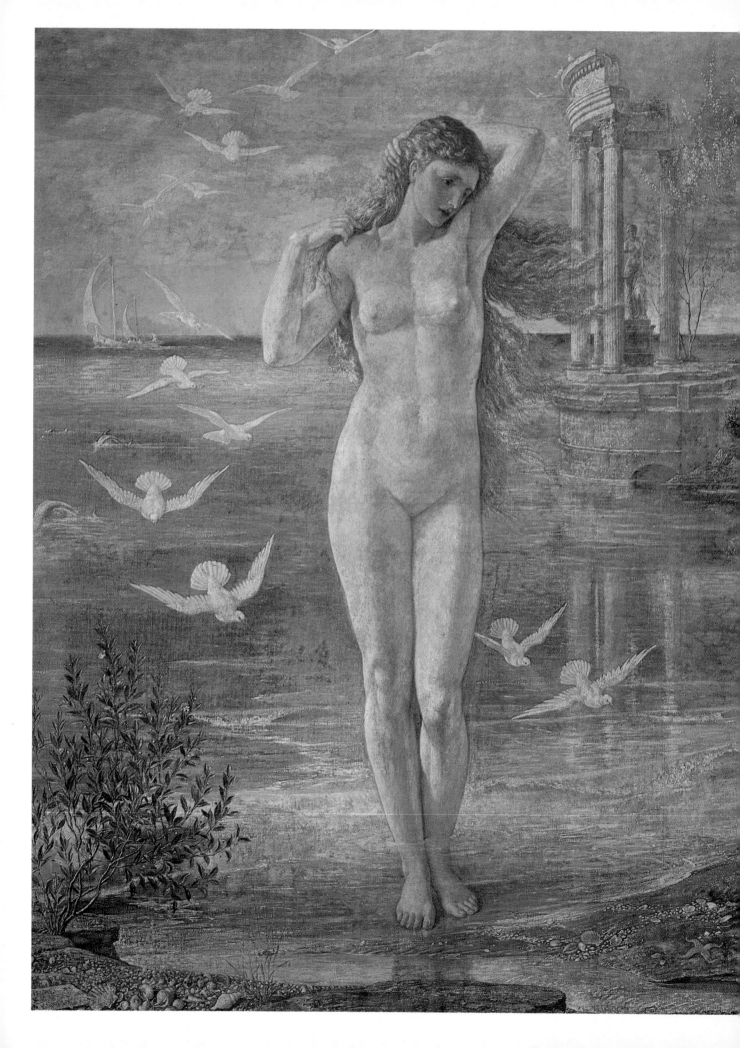

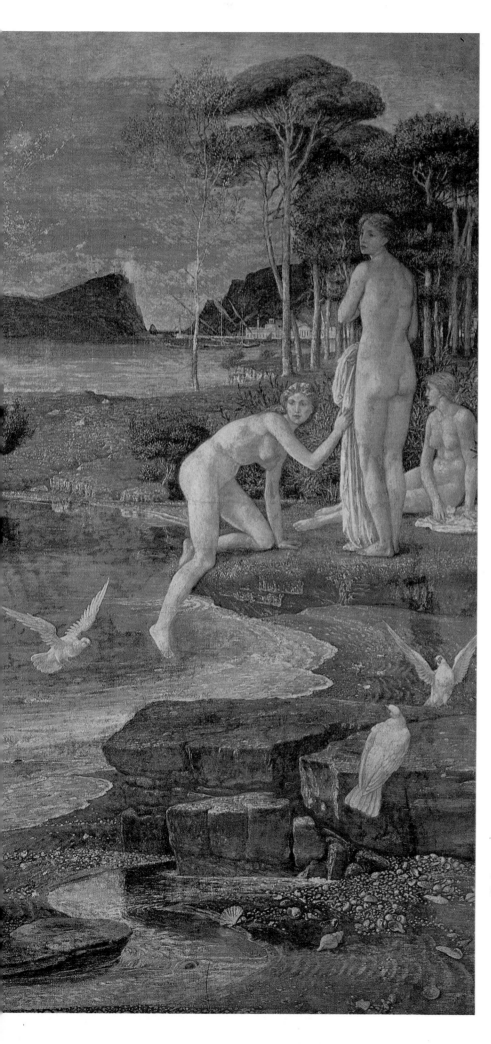

16. Walter Crane (1845–1915): *The Renaissance of Venus*. 1877. Tempera on canvas, 138.4 × 184.1 cm. (54½ × 72½ in.) London, Tate Gallery

25

to build his own palace of art. Throughout the winter of 1876-7 whilst the gallery was being built, Lady Lindsay's dinner parties had always numbered two or three painters or sculptors, introduced by Hallé, and in this way contacts had been secured. Not always, however, did they receive the approval of the Lindsays' butler, who once announced the arrival of Whistler (whose forelock was distinguished by a white streak) with the information that a guest had arrived with no tie and with a feather in his hair.

Sir Coutts had been careful to disguise the secessionist nature of this venture. In an almost identical statement made by the critic of the *Builder* and by the critic of *The Times*, and therefore probably originating from Sir Coutts, it was stated that the gallery had 'not been prompted by any spirit of animosity or jealous rivalry with the old-established societies of artists'. Moreover the decision to invite Royal Academy artists to exhibit further avoided any suggestion of dissent. Yet examination of the conditions under which the gallery was run reveals clear opposition to the Academy: admission was by invitation not by competition; an artist's paintings were hung all together with adequate space between each and next to work that was sympathetic, unlike the crowded conditions that prevailed at Burlington House, where the Royal Academy was housed. To ensure the best possible hanging conditions at the Grosvenor, Charles Hallé had made to scale a cardboard model of the galleries and the paintings to be exhibited. Such attention to detail contrasted with the Victorian tendency to cover every area of the wall, more or less haphazardly, with pictures.

Inevitably relationships between the Grosvenor and the Academy were strained. Most Academicians felt obliged to keep their best paintings for the annual summer exhibition: in 1877 Frederic Leighton sent to the Grosvenor Gallery nothing of importance; Millais sent

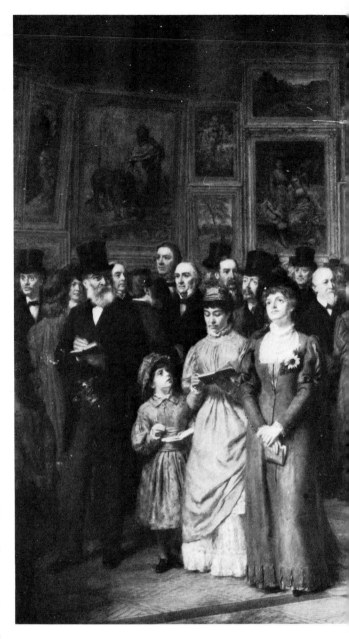

only portraits; and Poynter, although represented by twelve works, sent only small paintings, most of which had been previously exhibited. This attempt to mix the works of Academicians with those of outsiders, notably Burne-Jones, Whistler and Walter Crane, was

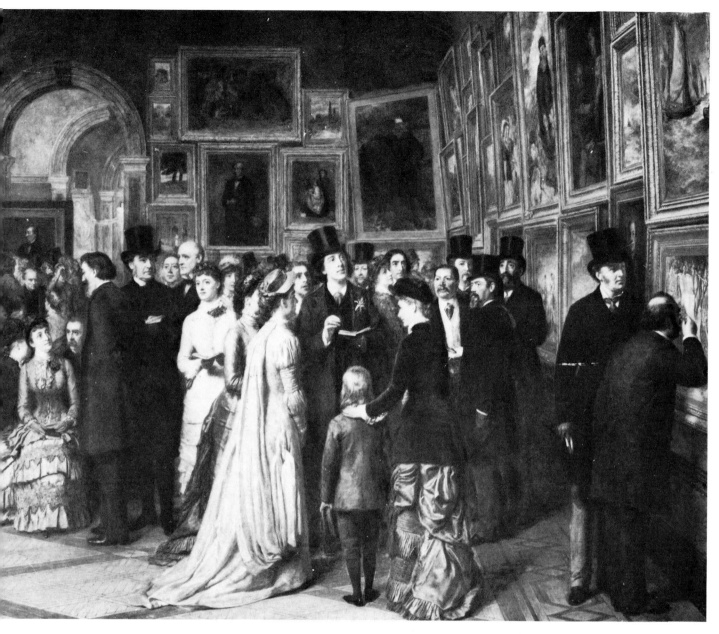

17. William Powell Frith (1819–1909): *The Private View at the Royal Academy*. 1881.
Canvas, 102.9 × 195.6 cm. (40½ × 77 in.) Private Collection

disagreeable to Rossetti, and for this reason he refused to exhibit. Partly because of Rossetti's non-appearance, together with that of Ford Madox-Brown, the leadership now passed to Burne-Jones.

The success of the first exhibition was repeated during the next ten years and the gallery attracted to its summer exhibitions the leading artists of the period. It was fortunate to flower when the Aesthetic movement was at its height and it quickly became associated with the craze for blue and white china, the

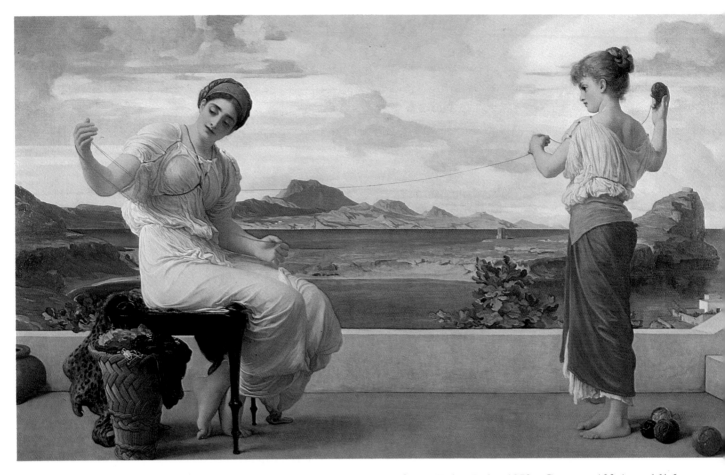

18. Frederic, Lord Leighton (1830–96): *Winding the Skein*. Exh. R.A. 1878. Canvas, 100.4 × 161.3 cm. (39½ × 63½ in.) Sydney, Art Gallery of New South Wales. An example of the more finished type of picture which Leighton kept for the Academy in preference to the Grosvenor Gallery

Queen Anne revival in architecture, the children's books designed by Walter Crane, Kate Greenaway and Randolph Caldecott. The classical draperies of Albert Moore's statuesque ladies encouraged a vogue for loose-flowing dresses. The more the movement spread, the more it became the butt of satirists, notably George Du Maurier, whose drawings kept *Punch* readers informed as to the latest inanities of the aesthetes (Plate 20). W. S. Gilbert in his libretto for the opera *Patience*, which satirized the appurtenances of

the movement as well as the new aesthetic man, included a specific reference to the gallery:

A pallid and thin young man
A haggard and lank young man
A greenery-yallery, Grosvenor Gallery,
Foot-in-the-grave young man!

The fashionable success enjoyed by the Grosvenor was partly due to Lady Lindsay's Sunday afternoon 'at homes' held in the gallery. At these she managed a deft interweaving of an artistic and social élite; the novelist, George Eliot, who had previously

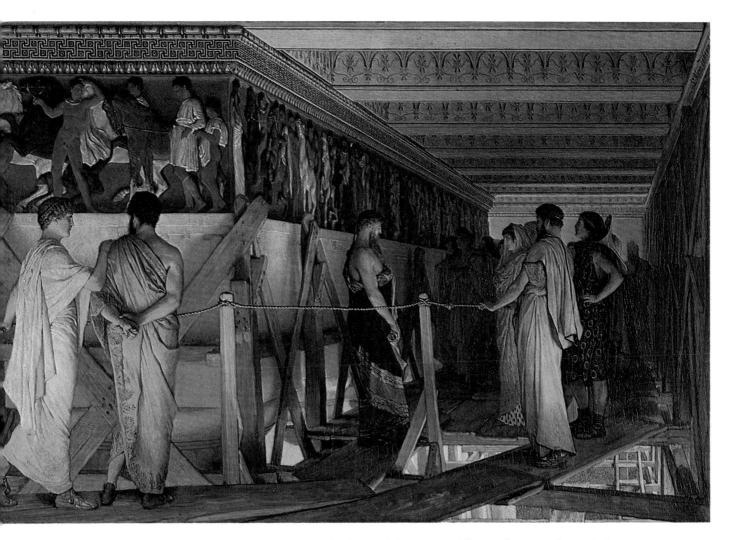

19. Sir Lawrence Alma-Tadema (1836–1912): *Pheidias and the Frieze of the Parthenon, Athens.* 1868.
Oil on panel, 72 × 110.5 cm. (28¾ × 43½ in.) Birmingham City Museum and Art Gallery

been regarded as a social outcast due to her decision to ignore the laws of wedlock and live openly with George Lewes, mingled with the famous beauty and no less notorious Mrs Lily Langtry; the difficult Whistler, capable of the most cutting remark, was a dangerous element in a society that included the Prince of Wales. Nevertheless Lady Lindsay presided over each occasion 'gushing and amiable', as Mrs Adams Acton recalled.

Lady Lindsay's departure in 1882, when she and Sir Coutts separated, was a sad loss for the gallery. She had contributed significantly to the financing of the venture and, from then on, Sir Coutts felt obliged to adopt a more commercial approach. This caused Burne-Jones much dismay and he wrote in protest to Hallé: 'I do seriously feel that . . . steadily and surely the Gallery is losing caste: club rooms, concert rooms, and the rest, were not in the plan, and must and will degrade it. One night we are a background for tobacco and another for flirting — excellent things both, but then not there.' Burne-Jones was not alone in his

29

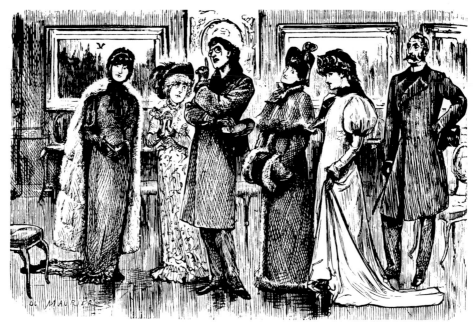

DISTINGUISHED AMATEURS.—2. THE ART-CRITIC.

Prigsby (contemplating his friend Maudle's last Picture). "THE HEAD OF ALEXIS IS DISTINCTLY DIVINE ! NOR CAN *I*, IN THE WHOLE RANGE OF ANCIENT, MEDIÆVAL, OR MODERN ART, RECALL ANYTHING QUITE SO FAIR AND PRECIOUS ; UNLESS IT BE, PERHAPS, THE HEAD OF THAT SUPREMEST MASTERPIECE OF GREEK SCULPTCHAH, THE ILYSSUS, WHEREOF INDEED, IN A CERTAIN GRACIOUS MODELLING OF THE LOVELY NECK, AND IN THE SUBTLY DELECTABLE CURVES OF THE CHEEK AND CHIN, IT FAINTLY, YET MOST EXQUISITELY, REMINDS ME !"

Chorus of Fair Enthusiasts (who still believe in Prigsby). "OH, YES—YES !—OF COURSE !—THE ILYSSUS ! !—IN THE ELGIN MARBLES YOU KNOW ! ! ! HOW TRUE ! ! ! !"

20. George Du Maurier (1843–96): *Distinguished Amateurs – 2. The Art Critic.*
Illustration reproduced in *Punch*, 13 March 1880

21. Edward Matthew Hale (*b.* 1852, *fl.* 1875–93): *The Three Princesses.* 1881. Canvas, 132.1 × 217 cm. (52 × 81½ in.) City of London, Guildhall Art Gallery. Exhibited at the Grosvenor Gallery in 1881. An example of the combination of sentiment with aesthetics that came to be associated with the Grosvenor Gallery. The subject is based on a chanson of the same title from Franche-Comté.

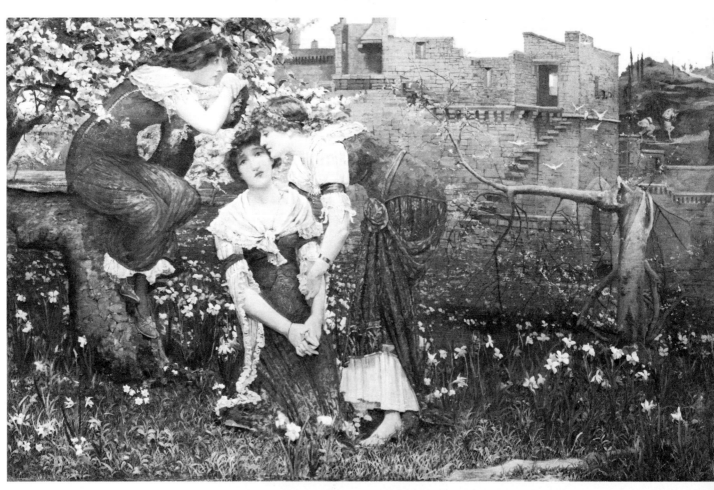

complaints: others expressed dislike of the huge posters emblazoned on either side of the main entrance advertising cheap dinners, luncheons, teas and oysters; Hallé and Joseph Comyns Carr, by then the two managing directors, disliked the introduction of Mr Pyke, the jeweller from next door, who knew or cared little for art but proceeded to manage the business affairs. The result was that Hallé and Carr resigned in 1887 and set up the New Gallery in Regent Street the following year. Burne-Jones and Alma-Tadema openly supported their decision and transferred their allegiance to the New Gallery, as did others, and the Grosvenor struggled on for a couple of years before closing in 1890. It became for a short period a clergymen's club, and Burne-Jones's celestial maidens were no doubt exchanged for the more terrestrial needs of sherry and cake.

For ten years the Grosvenor Gallery had become the focal point for certain artists whose work was inimical to the Royal Academy. It did not, however, establish an overriding aesthetic, being noted, rather, for its catholicity of taste. It was not a radical attempt to redirect nineteenth-century art, but primarily consisted of a circle of friends whose art was brought together and exhibited in an eminently upper-class establishment. Its fashionable success ensured that the late Pre-Raphaelite style, emanating chiefly from the art of Burne-Jones, was soon to be found in the work of others and on the walls of the Royal Academy. This style was, after all, closer to Leighton's classicism than to the emotional intensity and gauche designs of the original Pre-Raphaelites. Yet an echo of the poetic imagination awakened by the early Pre-Raphaelites tinged the art of the late Victorian period and lingered in people's minds long after they had left the exotic confines of the Grosvenor Gallery.

* * *

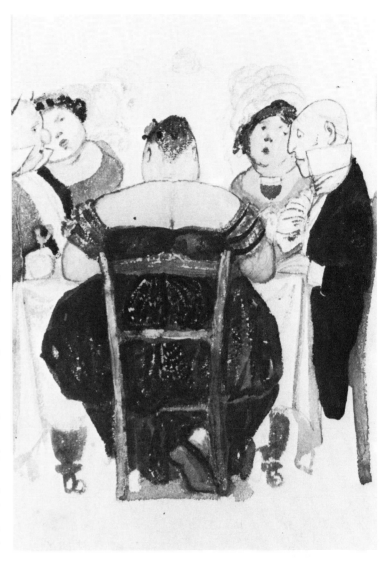

22. Sir Edward Burne-Jones (1833–98): *A Dinner Party*. About 1890. Pencil heightened with body colour, 27 × 19 cm. (10½ × 7½ in.) Private Collection. (Photograph courtesy of Sotheby's Belgravia)

31

Dreamer of dreams, born out of my due time,
Why should I strive to set the crooked straight?
Let it suffice me that my murmuring rhyme
Beats with light wing against the ivory gate,
Telling a tale not too importunate
To those who in the sleepy region stay,
Lulled by the singer of an empty day.
 WILLIAM MORRIS

Among the many paradoxes of the Victorian period, none was perhaps more striking than the contrast between the visual world artists saw around them and that which they chose to render in paint. 'One wonders how this sordid century could have such dreams and realize them in art', wrote Bernard Shaw. Apart from a few notable exceptions, late Victorian painting tells us little about social ills, the widespread illiteracy, prostitution, disease, hunger, alcoholism, riots, slums and harsh labour. When the railroads cut into the cities, destroying habitation and increasing the housing problem which had resulted from the sudden population explosion, it was ironically a foreigner, Gustave Doré, who left the most telling visual record (Plate 24). Even the socialist, William Morris, when he begins the prologue to the enchanted tales contained in his lengthy poem *The Earthly Paradise*, advises his readers:

Forget six counties overhung with smoke,
Forget the snorting steam and piston stroke,
Forget the spreading of the hideous town.

Burne-Jones, who was brought up in close proximity to some of the worst industrial slums in Britain, similarly wished to ignore both the

23. Sir William Blake Richmond (1842–1921): *Venus and Anchises* (detail). Exh. 1890. Canvas, 148.5 × 290 cm. (58½ × 116½ in.) Liverpool, Walker Art Gallery

24. Gustave Doré (1832–83): *Over London by Rail.* Illustration to *London: A Pilgrimage*, 1872, by Gustave Doré and Blanchard Jerrold

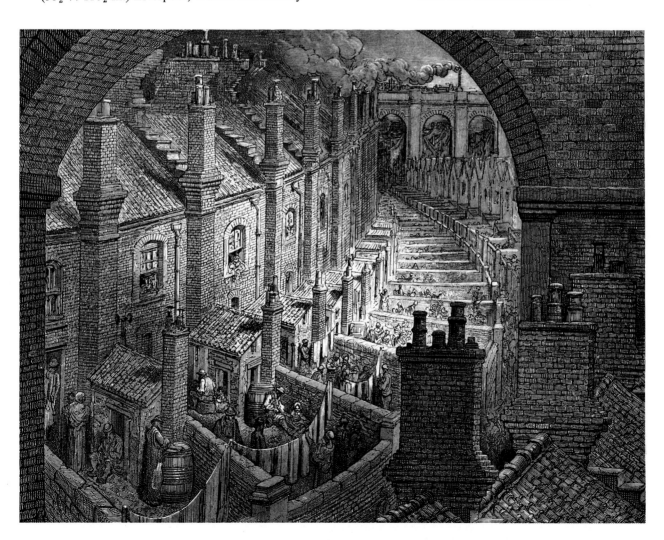

harsh realities of city life and its technological progress. 'The more materialistic science becomes,' he declared, 'the more angels shall I paint.'

Yet the art of this period cannot be described as pure escapism for it had as much to do with the longings and aspirations of the age as it was false to the externals of everyday life. It sought to satisfy not only the hunger for beauty that had been quickened by the effects of industrialization, but also the belief that art spoke a universal language which influenced the sensibility and moral values of the society in which it was produced. Burne-Jones believed that art should either please or exalt; Leighton declared there was no aesthetic sensation that was not infused with ethical or intellectual emotion; G. F. Watts, of whom it was said that he painted 'ideas not things', declared his aim to be 'to urge on to higher things and nobler thoughts'. This fusion of aesthetics and moral teaching was largely due to the influence of Ruskin, for whom a man's taste was an index to his moral state: 'Tell me what you like,' he wrote, 'and I'll tell you what you are.' Moreover, belief that art could inspire and improve led Leighton to be involved in the creation of the South London Art Gallery in Camberwell, Watts to loan some of his paintings to a church in Whitechapel and to receive visits from its 'largely criminal' parishioners in his studio, and Burne-Jones to exhibit his *Briar Rose* series at Toynbee Hall, where all who wished could see them free of charge (Plate 30). Stephen Spender's thought-provoking criticism that the Pre-Raphaelites 'refused to recognize that the basic condition of the life of every contemporary is that he is involved in the guilt of the whole society in which he lives', needs some modification, for the involvement was not with the surface aspects of the age but with the underlying intellectual and moral fabric on which its society was based.

Throughout this period Pre-Raphaelitism continued to exert considerable influence although the style had developed into something quite different from that which the original Brotherhood had set out to produce. The term 'Pre-Raphaelite' had first applied to the detailed, intense paintings produced by the young artists who formed the Pre-Raphaelite Brotherhood in 1848, among whom the leading figures were Dante Gabriel Rossetti, William Holman Hunt and John Everett Millais. But by 1854 the group had disbanded and only Holman Hunt continued to paint with the brilliant colours and microscopic detail of the original Pre-Raphaelite style. Millais had been elected to the Royal Academy in 1853 and his paintings gradually lost all trace of revolutionary fervour, whilst Rossetti developed a medieval dreamworld in a series of small watercolours. The latter gave rise to the second wave of Pre-Raphaelitism. Rossetti's magnetic personality attracted a number of followers (including Burne-Jones) who were never members of the original Brotherhood. The term 'Pre-Raphaelite' therefore, from the late fifties onwards, referred not to the sharp detail, bright colour and fitful interest in social realism of the earlier movement, but to the pseudo-medieval subject-matter and distinctive type of female beauty associated with Rossetti and Burne-Jones. And as far as the public was concerned, the Pre-Raphaelite movement was in the ascendancy by the sixties and reached its zenith in the eighties.

While at Oxford, Burne-Jones had first heard of Rossetti through his reading of Ruskin's Edinburgh lectures, the fourth of which was devoted to the early Pre-Raphaelites. After seeing a private collection of Pre-Raphaelite paintings in Oxford and discovering Rossetti's illustration, *The Maids of Elfen-mere* (Plate 26), in a book of William Allingham's poems, Burne-Jones went

25. Dante Gabriel Rossetti (1828–82): *The Wedding of Saint George and the Princess Sabra*. 1857.
Watercolour, 34.3 × 34.3 cm. (13½ × 13½ in.) London, Tate Gallery

to London in order to seek out the master, whose appearance perfectly fulfilled his expectations. Rossetti was in turn impressed by the young Oxford undergraduate: 'One of the nicest young fellows in – Dreamland,' he declared. Before long, Burne-Jones abandoned his intention to enter the Church and, with it, his university education, in order to become a pupil of Rossetti. The master taught no method but allowed Burne-Jones to watch him at work and advised him against study from the antique. The day's work would sometimes end with the consumption of a large bowl of strawberries and then Rossetti would urge Burne-Jones to accompany him on night wanderings through the streets of London or on visits to the theatre. Of this period, Burne-Jones later recalled: 'He [Rossetti] taught me practically all I ever learned; afterwards I made a method for myself to suit my nature. He gave me courage to commit myself to imagination without shame, a thing both good and bad for me. It was Watts much later who compelled me to try and draw better.'

Rossetti's night-life did not suit Burne-Jones and in 1858 he became seriously ill. He accepted an invitation to recuperate at Little Holland House, the home of Mr and Mrs Thoby Prinsep, and there came into daily contact with the resident painter, G. F. Watts, who conveyed to the young artist his admiration for Pheidias, the Greek sculptor, and for Venetian painting. Possibly inspired by Watts's *The Wedding of Buondelmonte*, which he would almost certainly have seen, Burne-Jones began work on drawings for a large oil of the same subject (Plate 29). Earlier, under Rossetti's influence, he had produced detailed pen and ink drawings of medieval subjects, in which the figures almost fill the entire composition and the quaint poses and concern with two-dimensional pattern suggest the influence of Dürer's engravings as well as

illuminated manuscripts. Some of the Buondelmonte drawings, however, reflect an increased maturity that may partly result from the influence of Watts and partly from Burne-Jones's first visit to Italy, made in 1859. They represent a transitional moment in his career, suggesting some influence of Italian art but still using the improvisatory technique developed under Rossetti, in which the main forms are sketched out in pencil and then small areas are densely worked, alterations being made as the work progressed. It was a method not dependent on a great deal of forethought, relying for its unity on the implied narrative, the compressed visual information and the staccato gestures that lead the eye across the page.

The gradual change in Burne-Jones's style towards increased clarification and harmony of design was encouraged by a second visit to Italy in 1862 made in the company of Ruskin, who set him to copy works by Titian, Luini, Veronese and Tintoretto. His admiration for Italian art was confirmed by subsequent visits, made in 1871 and 1873, when the example of Mantegna, Signorelli, Michelangelo, and others, led him to adopt simpler forms, larger, more significant gestures and more classical proportions. This development was possibly accelerated by the experience Burne-Jones gained from executing stained-glass designs for Morris's firm from 1860 onwards, for the nature of the medium demanded bold compositions and encouraged a more public style than that found in his early pen and ink drawings.

Burne-Jones later declared: 'If there had been one ancient Greek sculpture or one

26. Dante Gabriel Rossetti (1828–82): *The Maids of Elfen-Mere*. 1854. Pen and ink, 22.8 × 21.5 cm. (9 × 8½ in.) Illustration to *Night and Day Songs* by William Allingham. Present whereabouts unknown

36

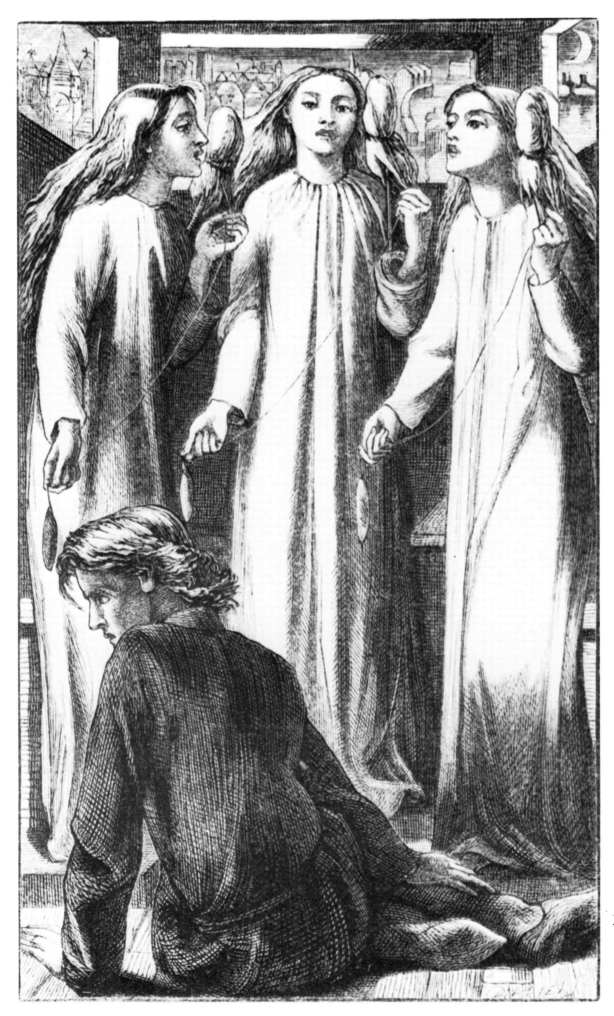

27. *Iris*. About 435 B.C. West Pediment of the Parthenon, Elgin Marbles. London, British Museum

28. Sir Edward Burne-Jones (1837–98): Drapery Study for *King Cophetua and the Beggar-Maid*. Pencil, 19 × 18.4 cm. (7½ × 7¼ in.) Wolverhampton, Wightwick Manor (National Trust)

faithful copy of a great Italian picture to be seen in Birmingham when I was a boy, I should have begun to paint ten years before I did.' Recognition of the need for standards in art led him, whilst living in Great Russell Street in the early 1860s, to pay regular visits to the antique sculpture galleries in the British Museum, which fairly bristled with the busy chalk and pencil of earnest students, absorbed in the study of the Elgin Marbles. Carlyle's opinion that not a single clever man was to be found among the Marbles because none of the jaws were sufficiently prominent, and his sweeping suggestion – 'I would away with them – into space,' – was not generally shared. On the contrary, their ruined grandeur cast a dominating influence on British art during the second half of the nineteenth century. Casts of the Marbles were to be found in most artists' studios; Alma-Tadema, who had admired the Marbles since his first visit to London in 1862, had a complete, small replica of the Parthenon frieze running around one room of his Townshend House.

Artists turned to classical and Renaissance sources to improve the quality of their

38

29. Sir Edward Burne-Jones (1833–98): *The Origin of the Guelph and Ghibelline Quarrel in Florence.* Illustration to the *Story of Buondelmonte.* About 1860. Pencil, pen and ink, 24.1 × 35.8 cm. (9½ × 14⅛ in.) London, Maas Gallery

draughtsmanship and this general trend led a number of critics, including Oscar Wilde, to talk of a renaissance when discussing the art of this period. The study of classical proto-types does, to some extent, justify the use of this term, but, on looking at the art produced, we often find that classical poses and draperies are used merely to house Victorian sentiment. However, if at times we feel we are present at an elaborate masquerade ball, at others the classical forms are fused successfully with an intense feeling for poetry, which had been awakened by the earlier Pre-Raphaelites.

The late Victorian period is, therefore, not really a renaissance – a rediscovery of past values – but rather the welding of a poetic imagination to an established taste. The result is a paradoxical art, borrowed yet intensely personal, studious yet freely imagi-native, presenting a late, hot-house flowering of the tradition that had begun with the Italian Renaissance.

* * *

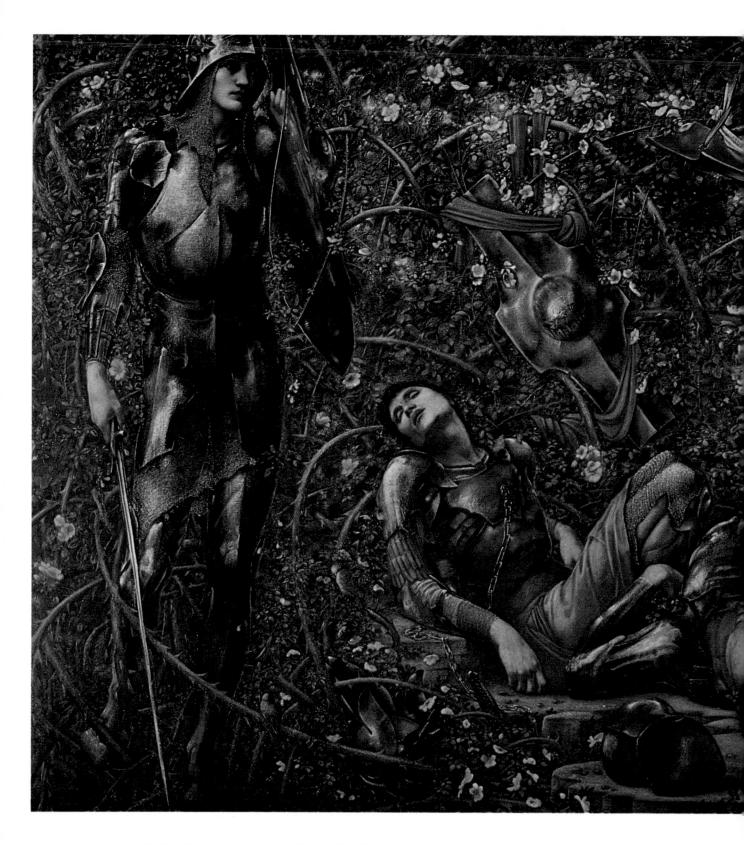

30. Sir Edward Burne-Jones (1833–98): *The Legend of the Briar Rose: The Briar Wood.* 1870–90.

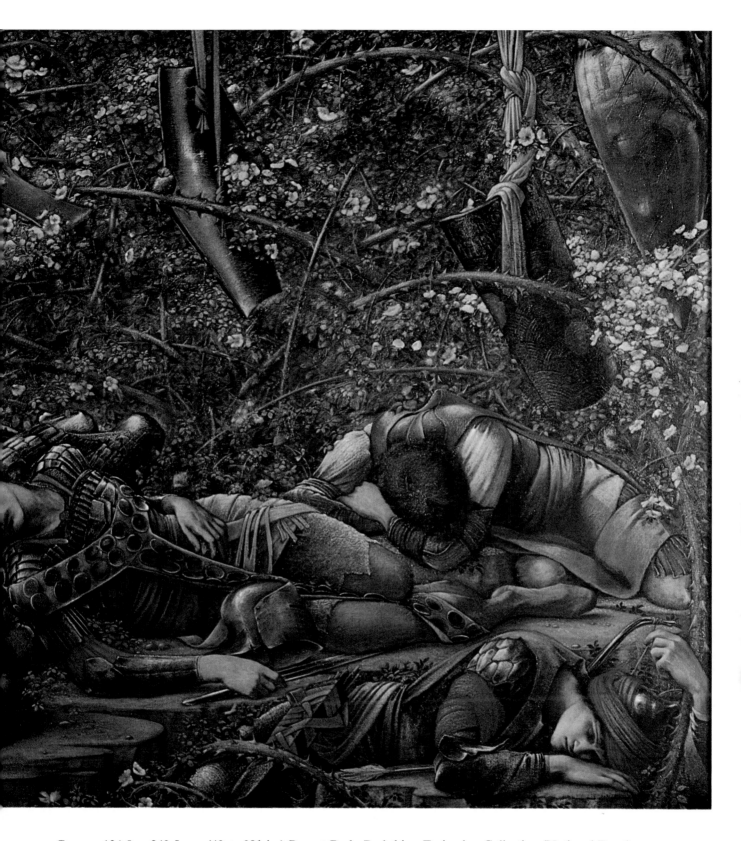

Canvas, 124.5 × 249.5 cm. (49 × 98¼ in.) Buscot Park, Berkshire, Faringdon Collection (National Trust)

41

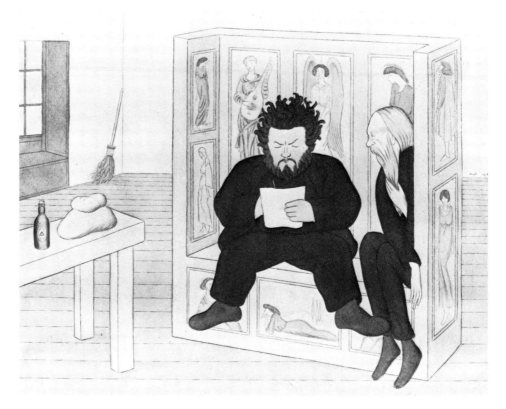

31. Max Beerbohm (1872–1956): *Topsy and Ned Jones settled on the settle in Red Lion Square*. 1916. Watercolour and pencil, 31 × 39.4 cm. (12¼ × 15½ in.) London, Tate Gallery (courtesy of Mrs Eva Reichmann, London)

The work of Burne-Jones has now come to be seen as an aesthetic challenge to the materialism of Victorian society. Certain background factors in the artist's life confirm this interpretation. As a boy, in Birmingham, he had come into contact with Cardinal Newman, who, he later recalled, taught him 'in an age of sofas and cushions . . . to be indifferent to comfort, and in an age of materialism . . . to venture all on the unseen'. This latter tendency was strengthened by his friendship with William Morris at Oxford; together the two friends read medieval literature and found in romantic chivalry the exact antithesis to the materialism of the age. The search for the Holy Grail, as Graham Hough, the literary critic, has remarked, needed no utilitarian justification, and Burne-Jones's love of medievalism was never accompanied by the social consciousness which it aroused in Morris; he never regarded it as a social or political ideal that could correct the evils of the day. However, his friendship with Morris would have ensured awareness of social and economic problems, and we know from a letter Burne-Jones wrote to Sidney Colvin that he intended, albeit unwillingly, to accompany Morris to the free speech demonstration held in Trafalgar Square on 13 November 1887, at which the Life Guards were called out to clear the mob and a young man was killed, giving rise to the name, 'Bloody Sunday'. If Burne-Jones's medievalism resulted partly from his desire to escape from external realities, the poignancy of his art is heightened by the knowledge that no lasting escape is possible.

Awareness of social change aroused in Burne-Jones the desire for a changeless order. 'I mean by a picture,' he declared, 'a beautiful romantic dream of something that never was, never will be – in a light better than any light that ever shone – in a land no one can define or remember, only desire . . .' The visions he

42

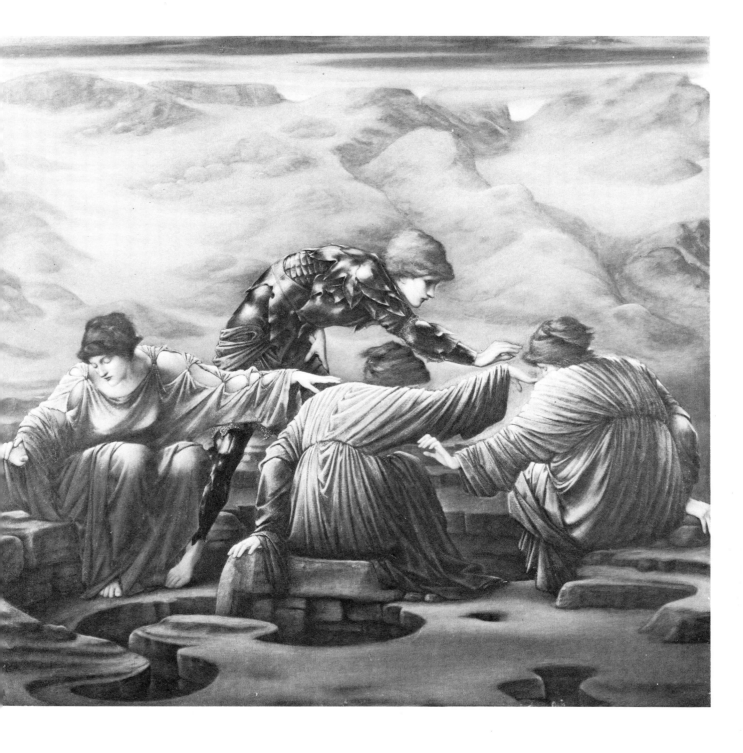

32. Sir Edward Burne-Jones (1833–98): *Perseus and the Graiae*. 1892.
Canvas, 153.5 × 170 cm. (60⅜ × 66⅞ in.) Stuttgart, Staatsgalerie

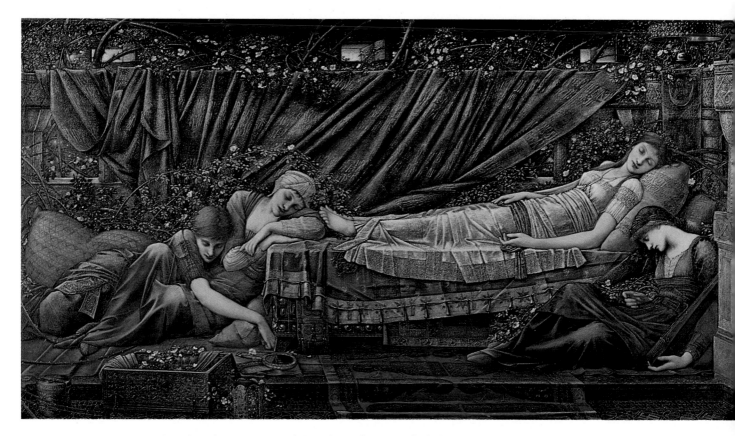

33. Sir Edward Burne-Jones (1833–98): *The Legend of the Briar Rose: The Rose Bower*. 1870–90.
Canvas, 125.7 × 228.6 cm. (49½ × 90 in.) Buscot Park, Berkshire, Faringdon Collection (National Trust)

produced are not the products of momentary inspiration but of continuous reworking of his ideas and persistent industry. Although self-conscious and lacking in spontaneity, the results are jewel-like, vibrant, mysterious and memorable. As he would often work on a picture at intervals over a period of many years, his studio was filled with half-finished products of his dreams. Surrounded by these during most of his working day, inner vision and outer world reinforced one another.

Burne-Jones based his dreams on Greek, Norse and Celtic legends, all of which he claimed he treated in the spirit of a Celt, that is with a sensitivity to the beauty and mystery of nature and with an inborn sense of melancholy. His choice of subject-matter was influenced by the literary circle in which he

moved, particularly by the enthusiasms of Morris, Rossetti and Swinburne. The main sources used were Malory's *Morte d'Arthur*, a storehouse of heroic legend, Chaucer, Tennyson, the lives of the saints and the Bible, but perhaps most important of all was Morris's *The Earthly Paradise*, a compendium of classical and romantic tales presented in a quasi-medieval style. The writings of Morris and Chaucer were peculiarly sympathetic to Burne-Jones due to their wealth of imagery and delight in decorative accessories. They enabled Burne-Jones to continue the medieval, romantic strain of earlier Pre-Raphaelitism, combining it with a new formal awareness that laid greater emphasis on the decorative qualities of design. His dream is an idyllic one, desiring not to teach a moral point but to

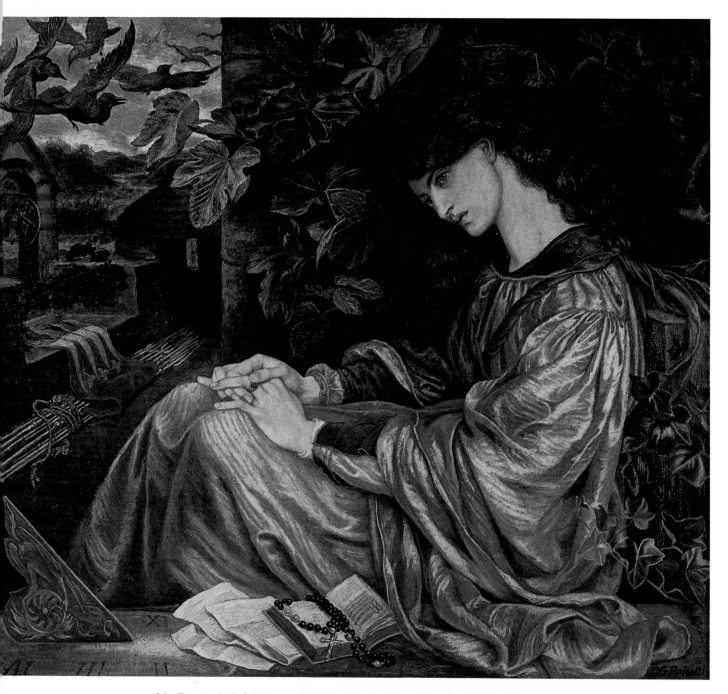

34. Dante Gabriel Rossetti (1828–87): *La Pia de'Tolomei*. 1868–80.
Canvas, 105.4 × 120.6 cm. (41½ × 47½ in.) University of Kansas, Lawrence, Museum of Art

exalt and inspire. Its aim and limitations are expressed in a line written by Walter Pater: 'Not the fruit of experience, but experience itself, is the end.'

Burne-Jones's delight in narrative led him to paint series of pictures depicting different scenes within a tale. His most original series was that based on the story of Perseus commissioned in 1875 by Arthur Balfour, later prime minister, for the drawing room of his home, 4 Carlton Gardens. The story was well-known to Burne-Jones through Morris's

45

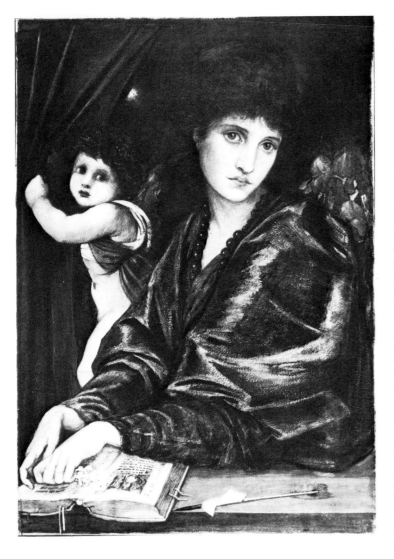

'The Doom of King Acrisius' in his *The Earthly Paradise*, which Burne-Jones had at one time intended to illustrate, although for his paintings he turned to a Latin source and departed from Morris's tale in a number of details. To enrich his approach to the tale, he visited the British Museum to study antique vases decorated with the Perseus legend and to look at the various ways in which the Medusa had been portrayed. This macabre tale concerning a land 'Desert and vast, and emptied of all bliss', demanded that Burne-Jones step outside the cloistered garden of medieval chivalry and enter a world that comes close to nightmare. In *Perseus and the Graiae* (Plate 32), which was not completed until 1892, Perseus creeps up on the three wailing crones who share one eye and is about to snatch it away as they pass it from one to the other, in order to wrest from them information as to the whereabouts of Medusa. It is typical of Burne-Jones's art that he should prefer to represent the moment before dramatic action in order to heighten the suspense. The rigid folds of the drapery create a sense of eerie ritual and contrast with the vacuous pockets of mist which fill the rocky landscape. Perseus's fantastic black armour heightens the mood of unreality; being the product of Burne-Jones's imagination, it frees the painting from association with any historical period. The painting creates a chill of horror at the same time as it haunts the imagination.

The facial expressions used by Burne-Jones in his art are often hopelessly inadequate; in *Perseus and the Graiae* the hideous, wailing crones are represented as demure young women. This limitation did not, however, mar his *Briar Rose* series, where apart from the prince every figure represented is asleep and therefore significant facial expressions are unnecessary. Produced between 1870 and 1890, as with the Perseus series there are various literary sources for this tale of the sleeping

35. Sir Edward Burne-Jones (1833–98): *Maria Zambaco*. 1870. Gouache, 76.3 × 55 cm. (30 × 21⅝ in.) Neuss, Clemens-sels-Museum. A member of the Greek community in London, Maria Zambaco posed for Burne-Jones and others and was a sculptress in her own right. Affected by her beauty, Burne-Jones makes a clear demonstration of his love for her in this portrait. She is accompanied by Cupid and around the arrow in the foreground is wrapped a piece of paper inscribed with her name and that of Burne-Jones.

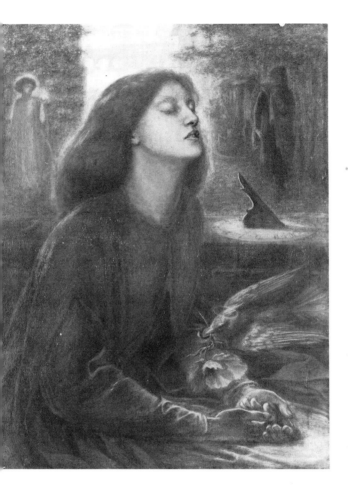

beauty; it is the subject of Tennyson's 'Day Dream', a poem that Burne-Jones would certainly have known, as it was included in Moxon's illustrated edition of Tennyson's poems published in 1857. Again Burne-Jones avoids the moment of dramatic action and, unlike Tennyson, does not show the awakening of the princess: nothing disturbs this mute world of frozen time (Plates 30, 33).

The main scenes represent the arrival of the prince in the wood, the sleeping court and king in the council chamber, then the sleeping young maidens in the courtyard and finally the princess herself lying on a bier. In all, the whiplash forms of the briar rose threaten to choke the scene at the same time as they contribute to the sustained decorative *tour de force* of the whole. Many of the chief qualities of Burne-Jones's art are found here: his use of variegated colour to enrich and echo the main colour harmonies; his use of line to establish the decorative rhythms; the delicate *sfumato* which gently moulds the faces and gives the sensation that his figures have been stroked into place; his avoidance of conflict or of any real check to the flow of movement across the composition; the expression of tender beauty rather than intellectual grasp of form. When seen in its setting at Buscot Park, the series as a whole is intensely moody, theatrical and strangely compelling in its suggestion of sleep. It can be interpreted as an allegory of love: the briar rose represents material desire which grows up and chokes the world, whilst the sleeping beauty represents the spirit of love which is capable of infusing the material world with spiritual life. Such an interpretation is confirmed by the lines Morris composed for the last scene:

Here lies the hoarded love, the key
To all the treasures that shall live.
Come, fatal hand, the gift to take
And smite this sleeping world awake.

Love was also the chief subject of much of

36. Dante Gabriel Rossetti (1828–87): *Beata Beatrix*. 1864. Canvas, 86.3 × 66 cm. (34 × 26 in.) London, Tate Gallery

47

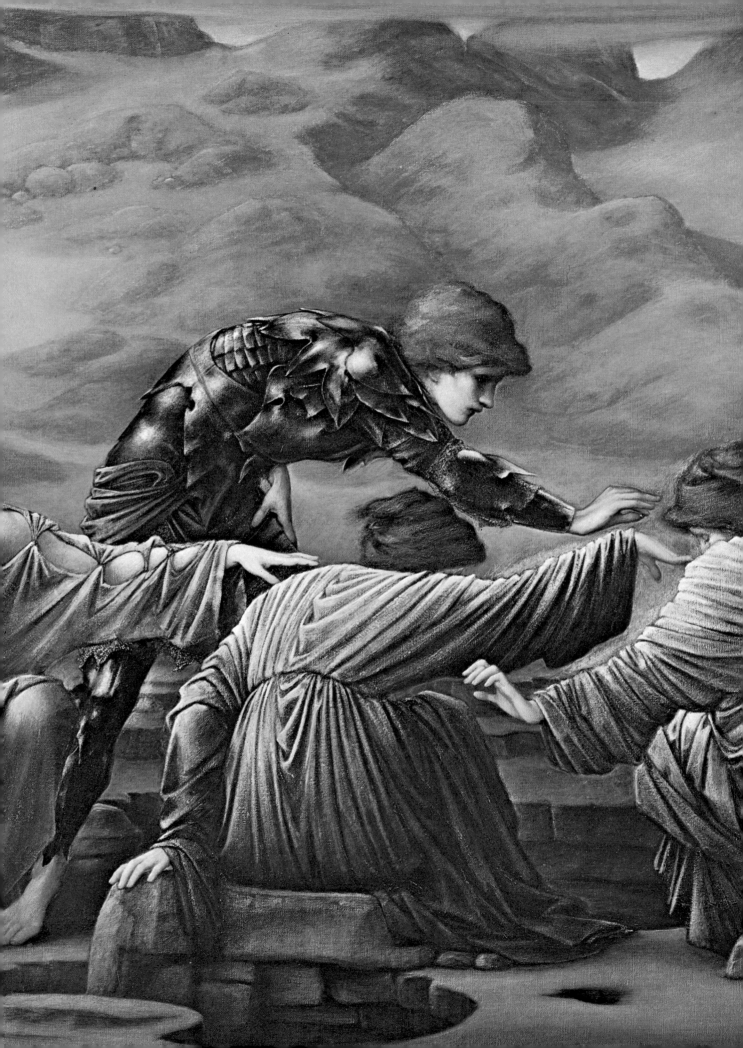

Rossetti's art, and, like Burne-Jones, he too spent the greater part of his life with his eyes closed to the external world. He told his biographer William Sharp: 'I do not wrap myself up in my imaginings, it is they that envelop me whether I will or no.' Walter Pater made a similar observation of Rossetti: 'Dream-land . . . is to him . . . a real country, a veritable expansion of, or addition to, our waking life.' This state was enhanced towards the end of his life by the strong doses of chloral, washed down with gulps of whisky, which he took to help cure insomnia.

After the death of Elizabeth Siddal, whom Rossetti had married in 1860, he used her likeness in one of his most famous paintings, *Beata Beatrix* (Plate 36), which represents the death of Dante's Beatrice not in actuality, but 'under the semblance of a trance'. Although in fact begun before Lizzie's death, Rossetti came to regard the picture as a memorial to her as well as an illustration to Dante's *Vita Nuova*. Dante gave no reason for Beatrice's death other than the fact that God, moved by her goodness, drew her up to heaven, so Rossetti here presents her suffused with an aureole of light, eyes closed, in communion with God. This fusion of the image of his beloved with that of Dante's Beatrice points to an underlying fabric of ideas that deepen the significance of Rossetti's persistent reworking of the female face.

At first sight, the paintings Rossetti produced during the last twenty years of his life appear far removed from the tender beauty pressed out in the shadows around the eyes, nostrils and lips of Burne-Jones's women. He underlines and enlarges just those qualities at which Burne-Jones merely hints: he uses the thickest

lips, the largest eyes, the richest curves, embroidered stuffs, flowers and jewels in order to make his dream as sensuous as possible. During the last ten years of his life, increased monumentality and stylization reduce these images to idealized types which affront the spectator with their mannerisms and cloying sensuality. But Rossetti's art is motivated by more complex forces than this emphasis on sensuality at first suggests. To grasp the full meaning of these iconic images one has to turn to his writings and to Dante's *Vita Nuova*, which he translated and which provided the underlying inspiration behind his life's work.

In the *Vita Nuova*, Dante, taking up the medieval tradition of courtly love, invests his love for Beatrice with religious significance and through his love for her is led into a state of grace, a theme further developed in the *Divine Comedy*. Rossetti's poems indicate that his exploration of the female image resulted from a similar mingling of physical and spiritual love. He asserts in the sonnet 'Heart's Hope':

Thy soul I know not from thy body, nor
Thee from myself, neither our love from God.

His lifelong concern to describe in both poetry and paint the beauty of women, parallels Dante's careful examination of his love for Beatrice in the *Vita Nuova*. Both are concerned to praise. Rossetti writes:

O Lord of all compassionate control,
O Love! let this my lady's picture glow
Under my hand to praise her name, and show
Even of her inner self the perfect whole.

The emphatic, large eyes he gives to his female portraits reflect Dante's belief that the eyes are the image of the soul, as expressed in the following passage from the *Vita Nuova*:

Forth from her eyes, wher'er her gaze she bends,
Come spirits flaming with the power of love.

Rossetti likewise read human and spiritual qualities into his facial features:

37. Sir Edward Burne-Jones (1833–98): *Perseus and the Graiae*. Detail of Plate 32

The mouth's mould testifies of voice and kiss.
The shadowed eyes remember and foresee.

In the *Vita Nuova* Dante's gradual definition of love shows how it can sharpen the senses, intellect and heart, heighten experience and lead the soul to salvation. Rossetti's representations of female beauty are governed by a similar spiritual quest; he regarded the painted images as in some way symbols of the state of his own soul, embodying his ideals, realizing his dreams. He gave expression to this belief in his Dantesque prose poem, 'Hand and Soul'. The story tells how an imaginary thirteenth-century painter, Chiaro dell'Erma, despairs of fame and faith and is visited one day by a mystical lady who says: 'I am an image, Chiaro, of thine own soul within thee, see me and know me as I am.' Written in a dream state, this tale gives symbolical expression to the belief on which Rossetti's life's work was based. 'All my life,' he declared, 'I have dreamt one dream alone.'

Considering the limitations of his imagery, Rossetti brought to his mature and later work an astonishing energy and invention. His representations of fleshed spirit take on a wide range of mood. *La Pia de'Tolomei* (Plate 34), a subject based on a figure in Dante's *Purgatorio*, expresses a listless melancholy for reasons that are explained in the lines translated from Dante and inscribed on the frame. Rossetti frequently made use of poetic quotations (often his own) to expand the meaning of the pictures, intending inscription and image to be experienced simultaneously. Here we are reminded that La Pia was imprisoned without reason by her husband in a fortress in the swamps of Maremma, where she pined and died. The last line of the poem refers to the 'fair jewel' with which she was wed, and this directs the eye to her hands, as she fingers her ring. Knowledge of the story is essential to our understanding of the picture and indicates Rossetti's unashamedly literary approach. He himself believed that both his paintings and writings sprang from the same source and that it was his poetic tendencies that gave value to his pictures.

In contrast to *La Pia*, the *Blessed Damozel* (Plate 38), based on Rossetti's poem of the same title, represents hope and love, directed from the spiritual heights of heaven to the lover left on earth below, but expressed with almost erotic overtones; in the poem Rossetti muses on whether the damozel's bosom makes warm the bar of heaven on which she leans and in the painting the madonna-type figure could hardly have been treated in more secular terms, the curves of her ripe lips echoing the full-blown petals of the lily in her hand. In the background, lovers, recently reunited in heaven, embrace, and beneath the damozel three angels intercede between her and her lover resting beside a stream in the predella below, the latter being added at the suggestion of William Graham, who commissioned the work. The painting is therefore divided into four sections in which the scale of the figures changes according to their importance. The shadowy, mysterious colours reflect Rossetti's love of Venetian painting, the wreathing patterns that suggest continual flux and the flickering of flames express a mood similar to that found in Walter Pater's conclusion to *The Renaissance*: 'To burn with this hard gemlike flame, to maintain this ecstasy, is success in life.' This apotheosis of the perfect woman remains a major statement in Rossetti's oeuvre, in essence a concentration of his life's passions and dreams.

The development of Rossetti's art away from the gauche, angular designs of his medieval watercolours to the voluptuous,

38. Dante Gabriel Rossetti (1828–87): *The Blessed Damozel*. 1875–8. Canvas, 174 × 94 cm. (68½ × 37 in.) Cambridge, Massachusetts, Fogg Art Museum

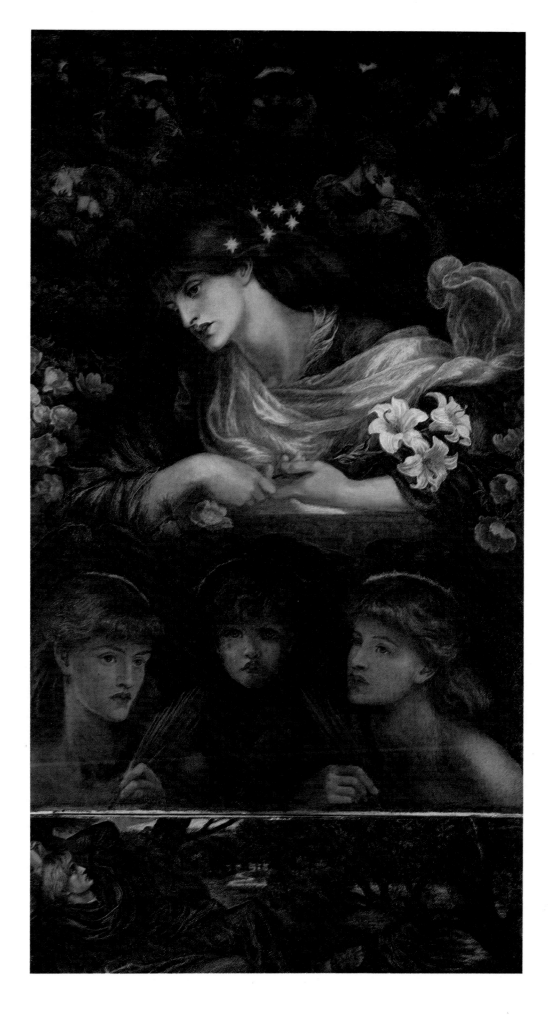

51

baroque curves of his fleshly ladies coincided, as it happened, with the rise of industrial wealth in the hands of a few, and it was amongst these *nouveaux riches* that he found his leading patrons. John Nicoll has suggested that Rossetti's art was perverted by current market forces, that the increase in rich, erotic, elaborate icons was partly in response to the taste of his patrons, who were very much less interested in the intense but modest products of his youth. It is, however, difficult to be exact as to how far Rossetti created or merely supplied the taste of his day. His female images were to a certain extent indebted to the emotional tenor of his age, but his personality was too dominant and his ideas too deeply developed within him ever to allow him to become a mere tool of fashion. The fact that industrial capitalism in England reached its apogee in the early 1870s, when Rossetti's art was at its most luxurious and seductive, is probably more coincidental than the result of cause and effect.

The concern with female beauty that dominates much late Victorian art arose partly out of the contemporary desire to glorify love. The images rendered in paint were often far removed from the physical reality which inspired them. If Rossetti's paintings of Jane Morris are compared with photographs of her, it can be seen that he softened the line of her jaw, toned down her eyebrows and mitigated those features that made foreigners laugh at her appearance when she travelled abroad. This divorce between reality and the painted image gave rise to the atmosphere of flawed idealism that enveloped these painters' personal lives. Watts, Burne-Jones and Rossetti all found their models at times more troublesome than their paintings might suggest. Rossetti's art depends on the successful intermingling of fact and dream; real-life features interpenetrate the abstract concern with design. Christina Rossetti, the

39. Dante Gabriel Rossetti (1828–87): *Annie Miller*. Pen and ink, 25.5 × 24.2 cm. (10 × 9½ in.) The Estate of the late L. S. Lowry. The sitter was a model whom Holman Hunt intended to educate and marry. On one of his visits to the East, Hunt unwisely left her in the care of Rossetti and during Hunt's absence artist and model were often seen in each other's company. On his return Hunt broke off the engagement. She later married and some years after Hunt met her by accident 'a buxom matron with a carriage full of children on Richmond Hill'.

52

artist's sister, aptly captures the essence of this transformation in her poem 'In an Artist's Studio':

> He feeds upon her face by day and night,
> And she with true, kind eyes looks back on him . . .
> Not wan with waiting, nor with sorrow dim,
> Not as she is, but was when hope shone bright;
> Not as she is, but as she fills his dream.

The spell cast by Rossetti's women continued to haunt artists even after his death. Ruskin declared that he had been 'the chief intellectual force in the establishment of the modern romantic school in England', and even Whistler referred to him as 'king'. But his personality was perhaps greater than his art and his far-reaching influence due less to his poetic imagination than to the legend that grew up around his name. This began with the trickle of publications that appeared in his own lifetime and developed into a deluge of books and articles after his death in 1882.

Frederick Sandys fell under the spell of Rossetti's sensuous dreams when he shared his house in Cheyne Walk, from the spring of 1866 until the end of 1867. Like Rossetti, Sandys concentrated on close-ups of female heads with various attributes brought into close conjunction in order to heighten the symbolism. His minute observation of flowers and fruit is Pre-Raphaelite, which is surprising as he first came to the attention of the group with his biting caricature of Millais' *Sir Isumbras at the Ford*. His female beauties, however, reveal his classicism, combined with a hint of the erotic, and a sense of drama. Thus his *Medea* (Plate 41) pauses in the act of concocting a fatal poison, one hand clutching at the coral beads around her neck. The electrifying union of evil and beauty evoked from Swinburne a glowing eulogy in praise of the painting when it was rejected by the Royal Academy in 1868. Swinburne has also left a vivid record of the Victorian interest in sensuality in his description of Sandys's

40. Frederick Sandys (1829–1904): *Proud Maisie*. Pen and crayon, 39.3 × 28.9 cm. (15½ × 11⅜ in.) London, Victoria and Albert Museum

53

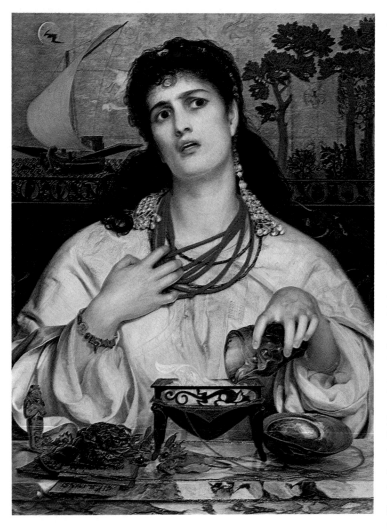

Proud Maisie (Plate 40): 'A woman of rich, ripe, angry beauty, she draws one warm long lock of curling hair through her full and moulded lips, biting it with bared bright teeth, which add something of the tiger's charm to the sleepy and couching passion of her fair face.' Sandys was also to make an important contribution in the field of illustration, and drawings, such as the above, led Rossetti to call him 'the greatest of living draughtsmen', an opinion he must have regretted expressing, as he later protested bitterly against Sandys's plagiarism of his work.

Another follower, from whom Rossetti had less to fear, was Val Prinsep. Before he had begun to train as a painter he was press-ganged by Rossetti into assisting with the Oxford Union decorations in 1857. He took some lessons from G. F. Watts and completed his artistic education under Gleyre in Paris, absorbing something of the French artist's classicism. But it was Rossetti who provided the inspiration behind his *Leonora di Mantua* (Plate 42), suggestive of an animal vigour waiting to spring into action. The fashionable beauty, however, lacks any trace of the mystery with which Rossetti endowed his women. Perhaps Prinsep recognized this as he later turned to scenes of social realism and eventually made his name at the Academy with a number of large historical paintings.

Evelyn de Morgan combined the brilliant palette of Rossetti with the draughtsmanship of Burne-Jones. The wife of the potter and (later) novelist, William de Morgan, she had attended the Slade School of Art at the age of sixteen and followed this with a period in Italy, staying with her uncle, the artist

41. Frederick Sandys (1829–1904): *Medea*. 1868. Oil on panel, 62.2 × 46 cm. (24½ × 18¼ in.) Birmingham City Museum and Art Gallery

42. Valentine Cameron Prinsep (1838–1904): *Leonora di Mantua*. Exh. 1878. Canvas, 167.7 × 124 cm. (66 × 48¾ in.) Liverpool, Walker Art Gallery

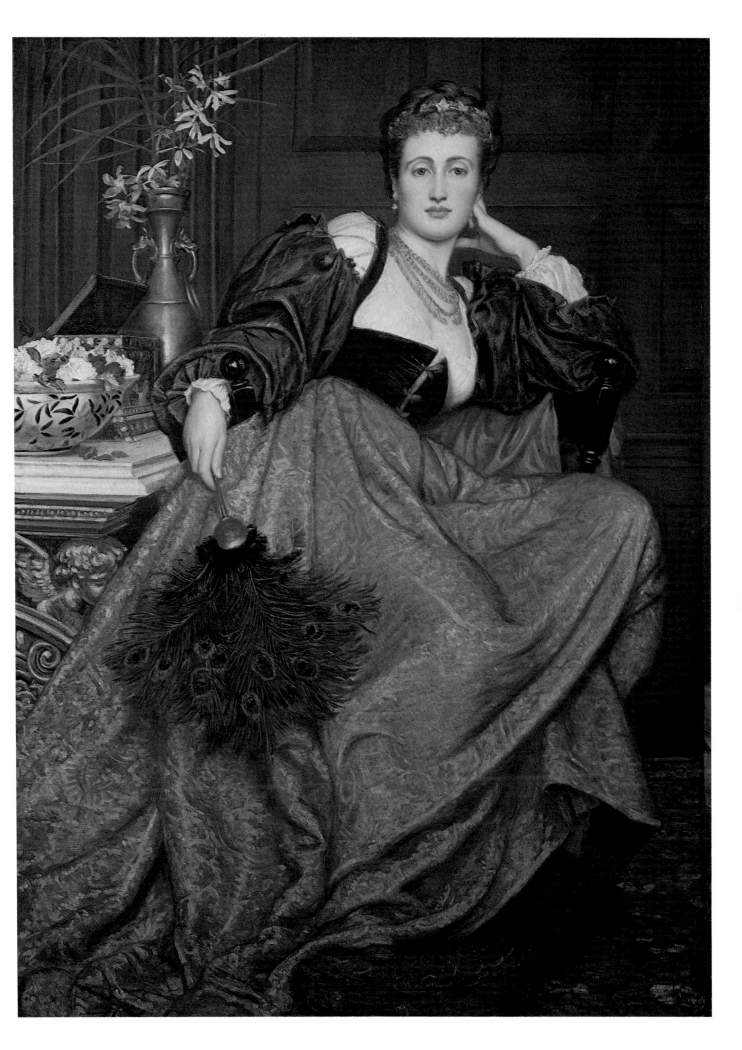

Spencer Stanhope, and becoming a lifelong devotee of Florentine painting, and of Botticelli in particular. She was twenty-one when the Grosvenor Gallery opened and exhibited *Ariadne in Naxos* (present whereabouts unknown), which won her considerable acclaim. Thereafter she exhibited regularly at the gallery. Her parents had originally intended that she should enter society but she persistently flouted convention, and was allowed instead to pursue a career in art. Her strong personality was married to a vivid imagination and she produced some extraordinarily elaborate allegories full of detailed symbolism. Their grandiose conception is often laboured, the poses at times unconvincing and the influence of Botticelli too obvious. None of these faults, however, mar *Aurora Triumphans* (Plate 44), an allegory on the triumph of Morning over Night; Morning is represented by a nude woman waking from the bondage of night, symbolized by the loosened ropes strung round her, whilst Night, a dark-haired, draped figure passes away with the clouds of night. According to May Morris, writing in an obituary note on Evelyn de Morgan, she painted from early morning until dusk every day for forty years. She lived well into the twentieth century, saw the introduction of Post-Impressionism, Cubism and Futurism into England, and was bewildered by this rude awakening.

Evelyn de Morgan's paintings demanded a considerable knowledge of classical myths; Cadmus and Harmonia, Boreas and Oreithyia, Phosphorus and Hesperus, Medea, are just some of the characters that figure in her work. Late Victorian art generally assumed an educated, literary audience. Since then, change in literary taste and the corresponding loss of interest in the moral questions these subjects imply, makes full appreciation difficult. The current dissatisfaction with formalist art criticism, however, has brought about a

return of interest in literary associations. Rossetti would have wholeheartedly approved of this recent refocusing of attention. 'A picture is a painted poem,' he declared, 'and those who deny it have simply no poetry in their nature.'

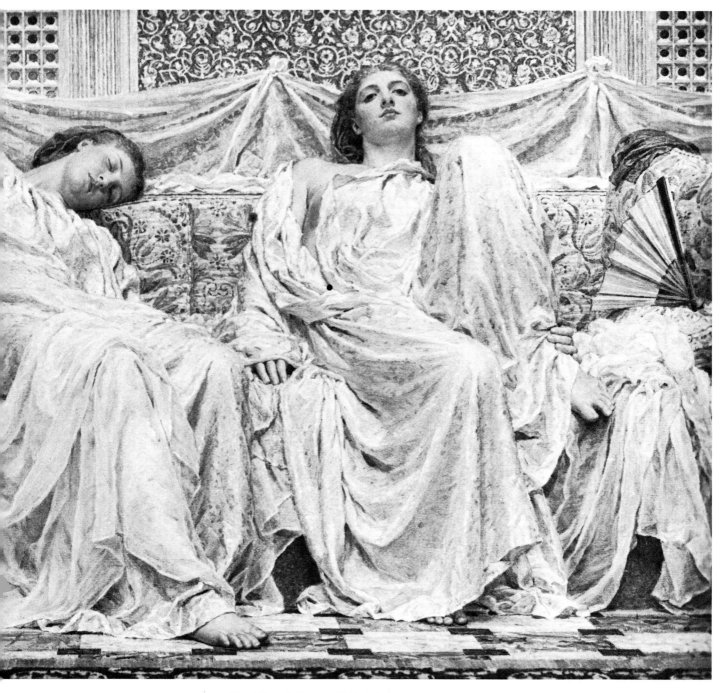

43. Albert Moore (1841–93): *Dreamers.* 1882.
Canvas, 68.5 × 119.4 cm. (27 × 47 in.) Birmingham City Museum and Art Gallery

The dominance of literature in Victorian art makes the work of Albert Moore more exceptional than it at first seems. Unable to appreciate its purely formal concern with classic harmony, Rossetti dubbed it 'pretty enough, but sublimated café-painting and nothing more' – implying that it had merely decorative value. Moore's commitment to purely aesthetic concerns, unsullied by literary, moral or anecdotal interests, makes him a forerunner of the twentieth-century interest in abstraction. Only the air of good breeding

44. Evelyn de Morgan (1855–1919): *Aurora Triumphans.*
Canvas, 116.9 × 172.7 cm. (46 × 68 in.) Bournemouth, Russell Coates Museum

evokes the suspicion that beneath their classical disguise his women are thoroughly Victorian. They act as the support structure on which he flaunts his skilful manipulation of line, texture and colour. *Dreamers* (Plate 43) is a full-blown example of his art in which every part is positioned to set up syncopated rhythms that enliven the somnolent scene. A moment of psychological tension is created when the eye suddenly rests on the face of the one female still awake, who stares straight out at the spectator. The lack of space, the dense folds of the drapery and the various textures are prevented from becoming claustrophobic by the languorous mood and the perfect ordering of the whole.

If Moore's monumental figures verge on the monotonous, they are enlivened by the frisson of the drapery. Moore excelled in the representation of fabric, particularly the semi-transparent kind; never as extravagant as Leighton's, less stiff and mannered than Burne-Jones's byzantine folds, his materials suggest movement without losing the sense of the forms underneath. Whilst painting *Sea-Shells* (Plate 45), he placed a fan beside his model to give the effect of a sea breeze. The painting also demonstrates his very refined sense of colour. He was particularly fond of warm-cool contrasts and the use of complementaries. After a walk through Kensington on a foggy morning he declared he had seen no colour

worth looking at except for some lemons laid out on blue paper on a costermonger's barrow. His colour sense was combined with an extraordinarily elaborate technique that involved numerous studies of the figure both nude and draped, a procedure that was simplified towards the end of his life by the use of photographs. The result was always one of the utmost refinement, a 'calculated loveliness' as Graham Robertson described it. Moore's position was neatly summarized by Swinburne: 'His painting is to the artists what the verse of Théophile Gautier is to the poets: the faultless and secure expression of an exclusive worship of things beautiful.'

Moore was never elected an Academician although he exhibited regularly at the Royal Academy from the 1860s onwards and continued to do so even after the Grosvenor Gallery provided him with more sympathetic surroundings in which to exhibit his art. His lack of specific subject-matter set him apart from the Academicians, but the aesthetic concerns that became the touchstone of his art are also to be found in the work of Leighton, Alma-Tadema and Poynter. Previously set apart as the 'Victorian Olympians', these artists were as much indebted to aestheticism as they were to the nostalgic and wistful mood of late Pre-Raphaelitism. Even Leighton, who, as president of the Royal Academy, brought to his art an Olympian calm and nobility, was not unaffected in his late works by Victorian sensuality, nor was he untouched by the yearning for an unattainable ideal. In his art the external world is again forgotten as we enter into visions of tragedy and grandeur.

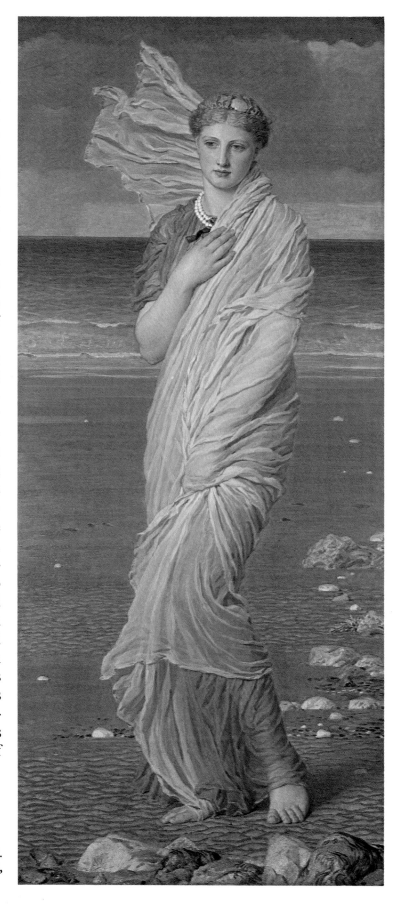

45. Albert Moore (1841–93): *Sea-Shells*. Exh. 1878. Canvas, 157.5 × 70 cm. (62 × 27½ in.) Liverpool, Walker Art Gallery

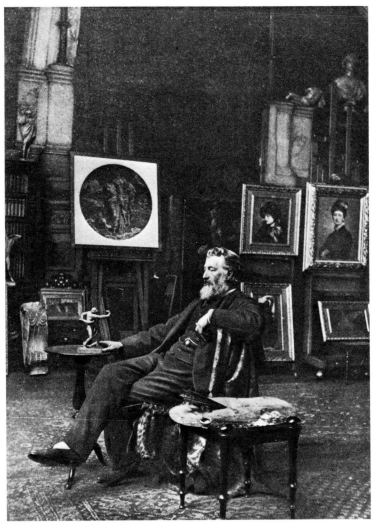

Leighton brings to his classical scenes not the timeless Celtic twilight in which Burne-Jones's figures exist, but a strong sense of daylight and air. His observation of light was developed by the small landscape paintings he executed when on holiday in Europe and Asia Minor. On his return to his studio, Leighton discarded the small scale of these intimate and surprisingly fresh studies, and, with the Royal Academy annual summer exhibition in mind, produced paintings which, in their sheer size and the care taken over obtaining a suitable frame, reveal the deliberate intention to impress. His masterpiece, *Captive Andromache* (Plate 48), is like a splendid stage set: the forms are well-rounded, every figure is deliberately posed and the whole is governed by a sense of rhetoric that lifts the scene out of everyday life and sets it apart in its magnificence. When first exhibited the painting was accompanied by a fragment of the *Iliad* translated by Elizabeth Barrett Browning:

Some standing by
Marking thy tears fall, shall say, 'This is she,
The wife of that same Hector that fought best
Of all the Trojans when all fought for Troy.'

All the main directional lines of the composition lead in towards the exiled Andromache, who stands alone, shrouded in black, waiting her turn to fill her water jug at the well. Her glance falls on the happy family group at the lower right, who reflect by contrast the pathos of her position. Every part of this immense canvas is orchestrated with considerable skill, one pose balancing the next and leading the eye from one form to another without crowding the picture or leaving awkward gaps. Leighton extracts the utmost from the means available like an

46. Frederic, Lord Leighton, in his Studio. Photograph reproduced in *Artists at Home*, Sampson and Low, 1884

47. Frederic, Lord Leighton (1830–96): *The Return of Persephone*. About 1891. Canvas, 203.2 × 152.4 cm. (80 × 60 in.) Leeds City Art Gallery

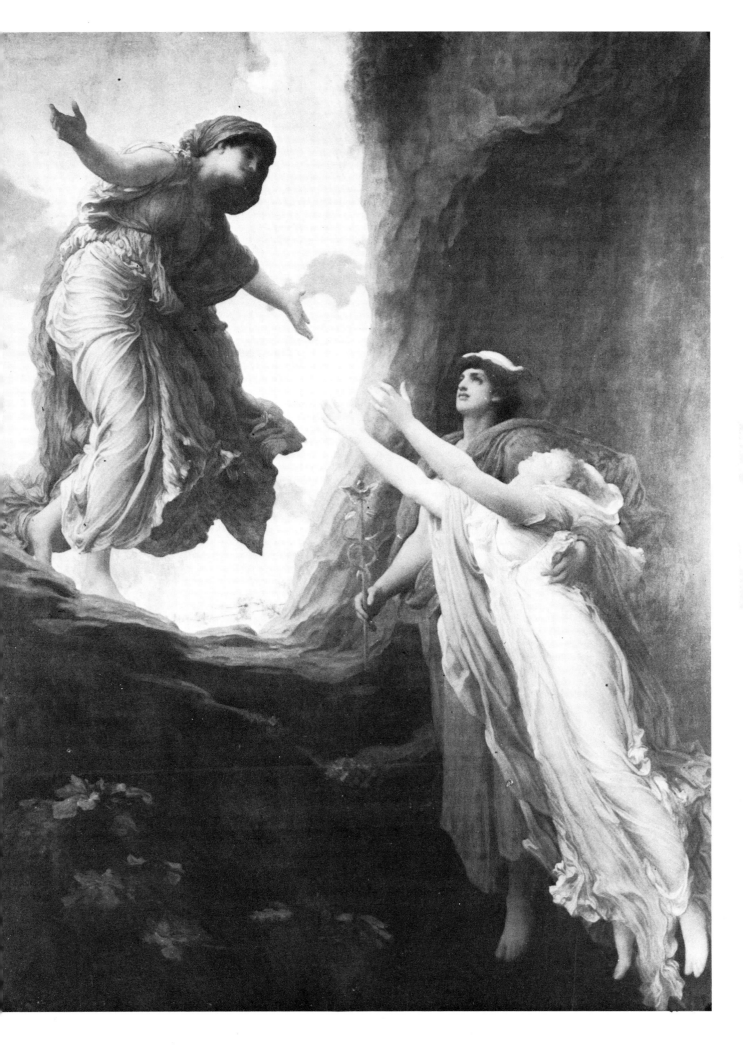

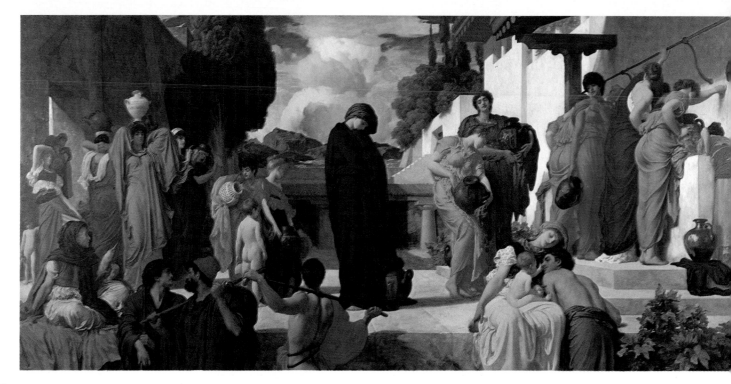

48. Frederic, Lord Leighton (1830–96): *Captive Andromache*. About 1888.
Canvas, 195.5 × 406.3 cm. (77 × 160 in.) Manchester, City Art Gallery

organist in full control of his instrument, manipulating the various stops in the most effective manner, yet the result, impressive and strenuous, is more satisfying to the intellect than to the emotions, which are left a little chilled.

Leighton frequently depends in his art on contrasts of light and shade: an arm in shadow will be balanced against a wing flooded with light, as in his *Daedalus and Icarus* at Buscot Park, or a lighted head will be set against a dark cloth or hood. This dramatic balancing of tone echoes across the picture surface, binding the composition together. It is used with considerable effect in the *Return of Persephone* (Plate 47), exhibited at the Royal Academy in 1891, which represents the moment when Persephone, who was carried away into the depths of the earth by Hades, is allowed to return for part of the year to her mother, Demeter, Goddess of the Earth, thus symbolizing the return of spring. Rippling draperies heighten the emotional tenor of the scene as

Persephone soars up to her mother, whose warm orange drapery contrasts with the pale robes of her daughter. Persephone's upward diagonal movement is balanced by her mother's outstretched arms. The effect of the whole is reinforced by the size of the canvas, which is over six foot in height.

If Leighton's art leaves the viewer with a feeling of awe, Alma-Tadema intended that his audience should feel comfortably at ease with his pictures. We could be Claudius behind the arras or one of the figures in the crowd in his *A Roman Emperor* (Plate 50), a scene that represents the moment when the centurions after killing Caligula and his family find Claudius in hiding and carry him off to proclaim him Emperor. This peep-show element in Tadema's art gradually increased

49. Sir Edward Poynter (1836–1919): *On the Terrace*. Exh. R.A. 1889. Oil on panel, 59.5 × 42.2 cm. ($23\frac{7}{16}$ × $16\frac{5}{8}$ in.) Liverpool, Walker Art Gallery

62

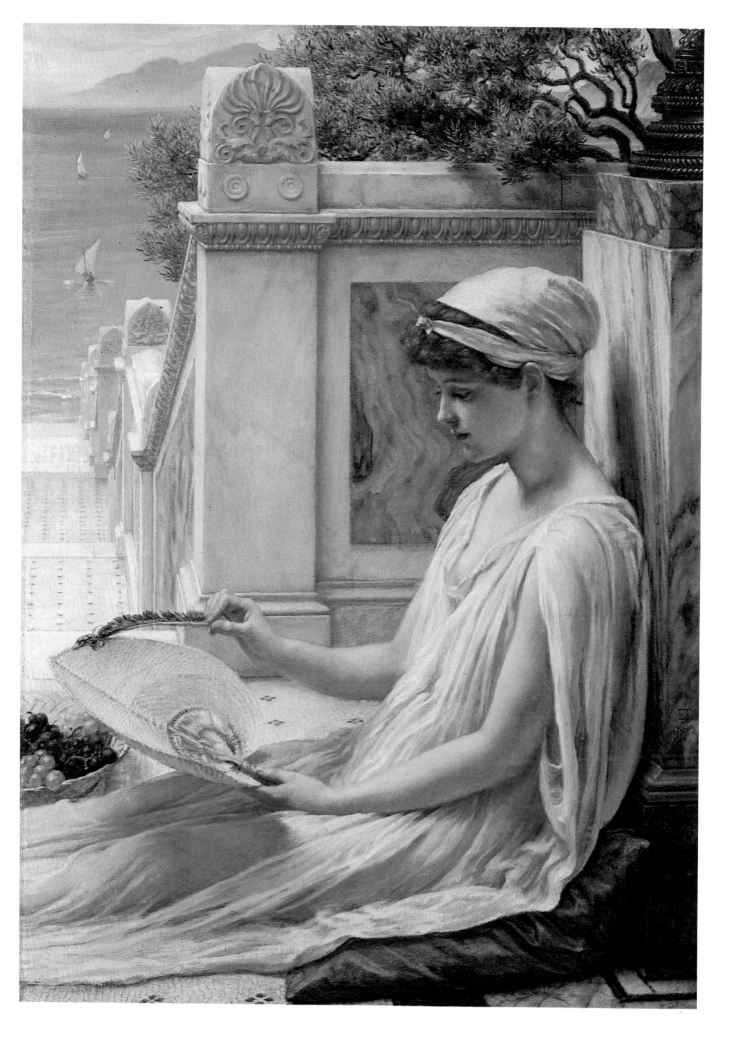

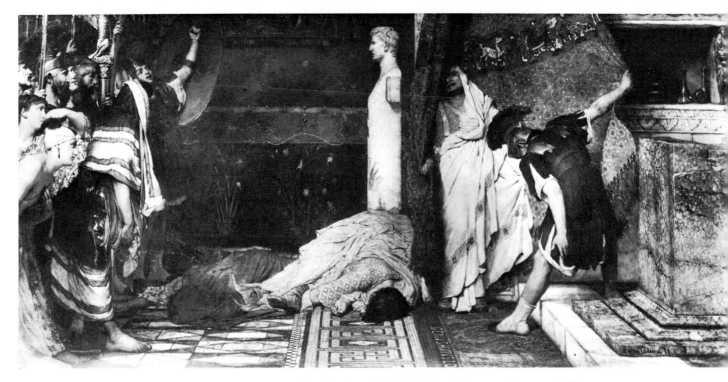

50. Sir Lawrence Alma-Tadema (1836–1912): *A Roman Emperor*. 1871.
Canvas, 83.8 × 174.2 cm. (33 × 68⅜ in.) Baltimore, Walters Art Gallery

as the century developed and in the Edwardian period it often took on the aspect of titillation. His art relies on familiarity; his Roman men and women are experiencing emotions that could easily be felt by his Victorian public. Ernest Chesneau, the critic, wrote that Alma-Tadema 'put the antique world into slippers and dressing gown'. His paintings are meticulously painted day-dreams, heightened by the use of *trompe-l'oeil* illusion. The exact archaeological reconstructions house not the high, tragic events of ancient history, but more intimate domestic scenes. His ladies yearn, as do Burne-Jones's maidens and Leighton's goddesses, but for more sentimental reasons; they loll on marble benches covered with furs and confide to each other their secret desires, or they lean on ramparts overlooking the Mediterranean awaiting the return of the men. This emphasis on the everyday events of ancient life reflects Tadema's reading of Bulwer-Lytton's *The Last Days of Pompeii*, which was first published in 1834 and rapidly

became a popular classic. Its pages are littered with references to ancient Roman objects and customs in a similar way to that in which Tadema's still-lifes protrude on the eye. Tadema also took part in the vogue for problem pictures, whose titles aroused speculation but did not fully explain the image presented. Such paintings provided the starting point for after-dinner conversation and were therefore a social asset. Moreover, Tadema's paintings had a particular appeal to the self-made merchants and industrialists: such correct reconstruction of ancient Greece and Rome implied classical learning on the part of the owner, who may well have lacked the classical education of the upper classes.

The attention to detail and occasional use of brilliant colour led certain critics to discover a Pre-Raphaelite element in Tadema's art. His close observation of surface texture is however equally indebted to Dutch seventeenth-century painting, as is his use of the contrast between a dusky interior and the

64

glimpse through a doorway of bright light, a motif found in the work of Pieter de Hooch. In *The Oleander* (Plate 51) the cool interior is heightened by the bright sunlight and sea seen through the doorway; this compositional device recurs frequently in Tadema's work of the 1870s. He also excelled at the subtleties of reflected light on marble, to such an extent that it, occasionally, detracts from the emotions of the figures represented. Paintings such as *The Secret* (Plate 53) led *Punch* to label Tadema a 'marbellous painter'. Skill and attention to finish give his paintings an expensive look, as attractive to their owners as the easy sentiment on which he drew. The subject is always pleasure and not passion, but this, as Tadema realized to his profit, was in keeping with the demands of his contemporaries, who, he declared, wanted 'cheerful things'.

Tadema had been slightly preceded in his reconstruction of ancient scenes by Edward Poynter, who in 1864 enjoyed great success at the Royal Academy with his *On Guard in the Time of the Pharaohs*. He followed it in 1865 with his famous *Faithful unto Death*, representing the Roman soldier who refused to leave his post during the fateful eruption of Vesuvius in A.D. 79. To build on the success of these two paintings, Poynter determined to spend two years producing a *tour de force* entitled *Israel in Egypt*, an immense canvas filled with numerous figures, exhibited at the Academy in 1867 (Plates 52, 54). It illustrated a passage in the Book of Exodus which describes how the Egyptians made slaves of the Israelites and forced them to build the towns of Pithom and Ramses. The painting was bought by Sir John Hawksmoor, a celebrated engineer, who observed that the number of slaves pulling the stone sphinx was insufficient to move the weight. The painting was therefore returned to Poynter, who added new figures, which gradually disappear in a diagonal off the

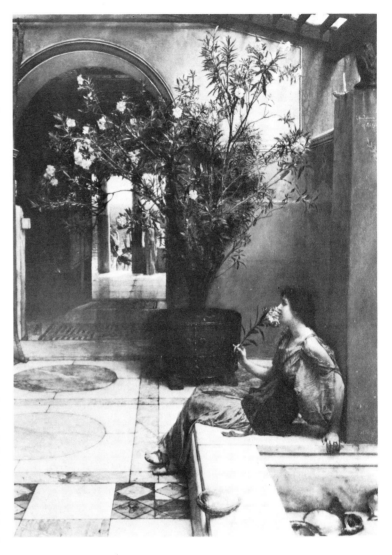

51. Sir Lawrence Alma-Tadema (1836–1912): *The Oleander*. 1882. Panel, 91.4 × 65.4 cm. (36 × 25¾ in.) Private Collection, U.S.A. (Photograph courtesy of Fine Art Society, London)

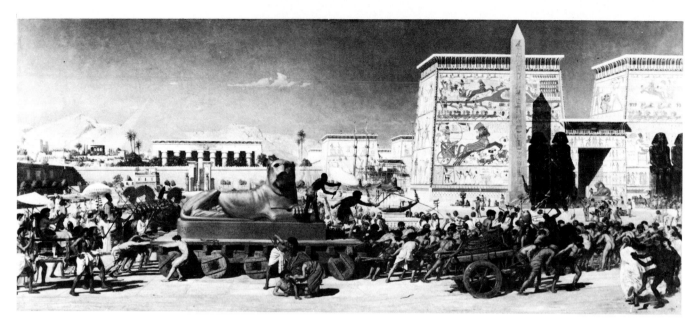

52 and 54. Sir Edward Poynter (1836–1919): *Israel in Egypt*. 1867.
Canvas, 137.2 × 317.5 cm. (54 × 125 in.) City of London, Guildhall Art Gallery

53. Sir Lawrence Alma-Tadema (1836–1912): *The Secret*. 1887.
Panel, 44.6 × 53.3 cm. (17½ × 21 in.) Brighton, Royal Pavilion, Art Gallery and Museums

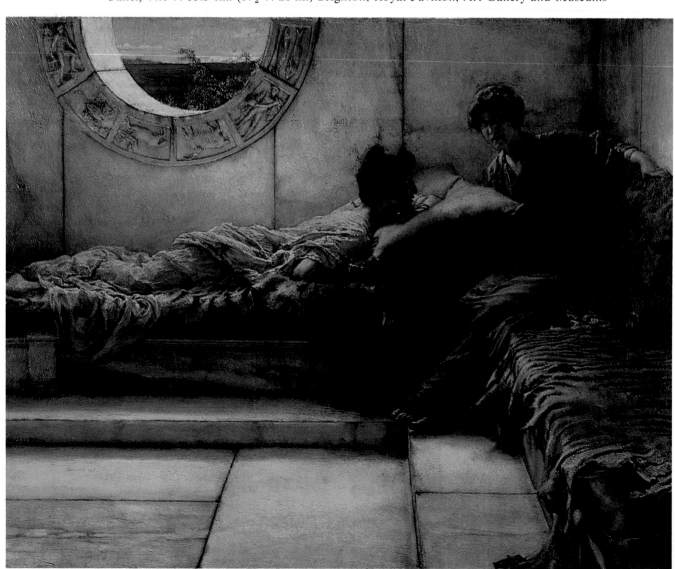

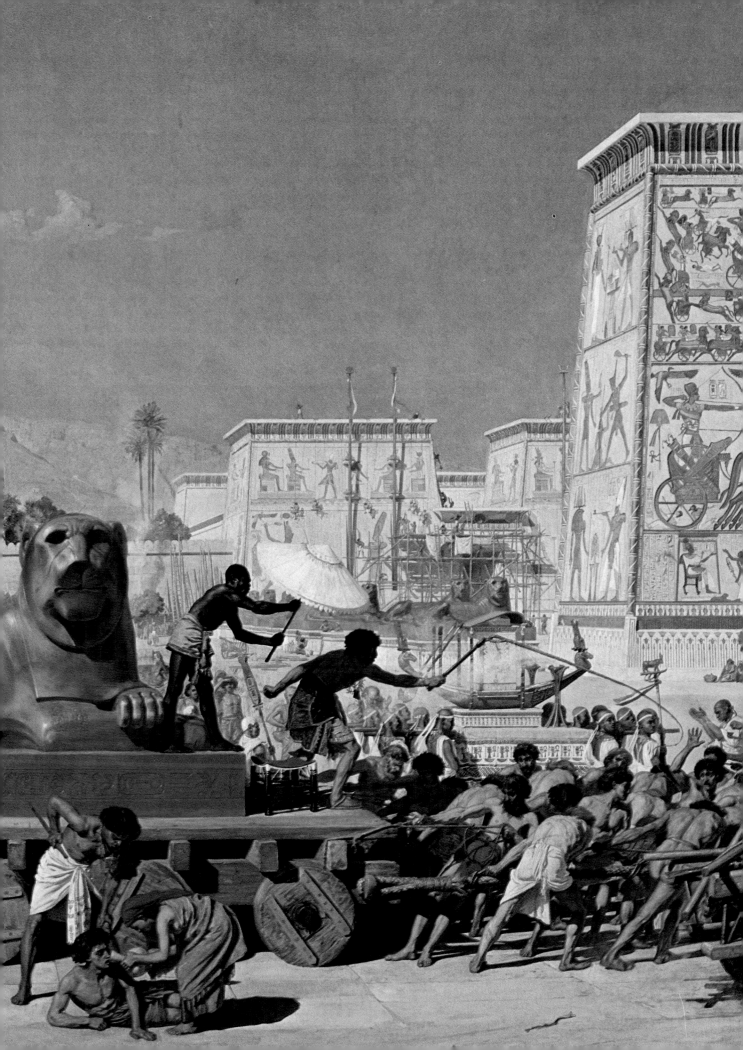

55. George Frederic Watts (1817–1904): *Time, Death and Judgement*. Canvas, 106.8 × 81.3 cm. (42 × 32 in.) Sheffield City Art Galleries

right-hand side of the picture, suggesting an unlimited number. Despite the small scale of the figures in relation to the size of the canvas, every group is animated by a lively, complex sense of rhythm, demonstrating the art of balanced composition that Poynter had learnt during his three years training under Gleyre. Moreover the brilliant sunlight and shadows allowed him to extend this sense of balance to the manipulation of tone, which is best seen in the sensitive rendering of the landscape under a heat haze. When in the following year he consolidated this achievement with *The Catapult*, a smaller, but similarly complex illustration of energetic action, he was elected an associate of the Royal Academy.

During the 1880s Poynter went on to produce a number of paintings that are similar in subject and approach to those of Alma-Tadema. He too could bring to bear, on the most insignificant of moments, an extraordinary power of observation and subtlety of execution, as can be seen in *On the Terrace* (Plate 49), in which a young girl teases with a quill a beetle that has landed on her fan. Poynter employs a shock tactic, often found in Tadema's art, of abrupt perspectival juxtapositions, by placing a far distant view of the sea in direct relation to the close-up of the girl. His marble, maiden and Mediterranean are as convincing as Tadema's and his subject-matter could at times be equally seductive. But here the similarities end, for Poynter lacked the Dutchman's flair for the unexpected viewpoint, nor did he attempt to evoke the same psychological appeal. Despite his classical tendencies, his *métier* was probably portraiture and landscape water-colours, and during the last years of his life he turned more and more to the latter, producing detailed scenes of his Kensington garden and of the places he visited abroad.

Whilst Alma-Tadema and Poynter resorted to the elaborate representation of domestic

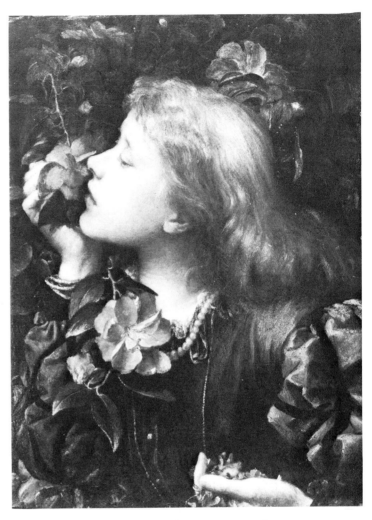

56. George Frederic Watts (1817–1904): *Mary Watts.* 1887. Canvas, 53.3 × 35.5 cm. (21 × 14 in.) Compton, Surrey, Watts Art Gallery. Watts married Mary Fraser Tytler, his second wife, when she was thirty-six and he sixty-nine years of age. As her half-brother handed her over at the marriage service, he murmured: 'I give you to the nation.' Mary Watts contributed greatly to the artist's late years. These were extremely productive and the marriage was a happy one.

57. George Frederic Watts (1817–1904): *Choosing.* About 1863. Canvas, 47 × 35.5 cm. (18½ × 14 in.) London, National Portrait Gallery. A portrait of Ellen Terry, Watts's first wife, whom he married in 1864. They parted the following year and the marriage was dissolved in 1877. Ellen later recalled that Watts had been 'old for his age . . . nervous about his health and always teetering about in galoshes'. She is shown here in the act of choosing between the showy but scentless camellias and the humble, fragrant violets held close to her heart. This demure girl was later to emerge as one of the leading actresses of her age.

subject-matter, G. F. Watts remained firmly in the realm of high art. He declared his intention as follows: 'I want to make art the servant of Religion by stimulating thought high and noble. I want to assert for art a yet higher place than it has hitherto had.' His own religious beliefs being somewhat nebulous and vague, he was careful to avoid dogmatism in his attempt to put the grand manner at the service of contemporary ideals. As a result

69

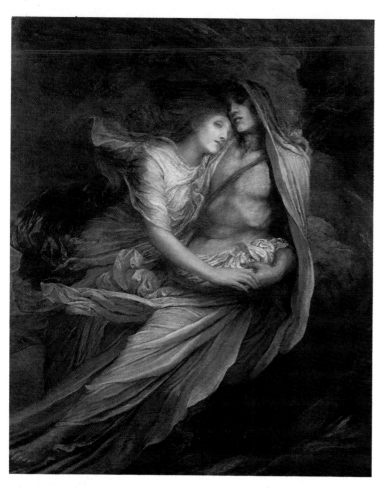

58. George Frederic Watts (1817–1904): *Paolo and Francesca*. Canvas, 152 × 129.5 cm. (60 × 51 in.) Compton, Surrey, Watts Art Gallery

his allegories on Faith, Hope, Love, Life and Death are often strangely enigmatic and evade analysis. The limp, blindfold figure of Hope, seated on a sphere, plucking half-heartedly at the single string of a harp, must, however, have aroused considerable moral speculation as it was one of his most popular works. *Time, Death and Judgement* (Plate 55) shows Time with a scythe leading the pale figure of Death, who mournfully gathers up flowers in her skirt as they wade through the stream of life, while, following close behind, Judgement wields his sword of justice, or, in other versions of the subject, holds out a pair of scales. This was the only painting that Watts claimed came to him as a vision in his mind before he began to paint; the other allegories were developed by intuition and the combination of mind and eye as the painting progressed.

Watts's most ambitious project, however, was never realized. His aim was to decorate a public building with the history of the world and 'the progress of man's spirit', a noble enough theme, but not one that any public body was prepared to commission. Earlier in his career, Watts had offered to decorate the hall of Euston Station with no doubt similarly elevated subject-matter, for the price of his materials only, but the London and North-Western Railway Company had politely refused his offer. This desire to recreate the Sistine Ceiling is surprising for a man of such small stature, physically debilitated by regular evening meals of cold puddings made without sugar and a glass of milk mixed with barley water. But, as Chesterton pointed out, Watts had the one great certainty which marked out all great Victorians; it was the certainty not that he was successful, great, or capable of good, but that he was right. His abstract ideas, conveyed at times with a didactic simplicity, combined with a Titianesque technique and a palpitating, tremulous touch, created deeply glowing

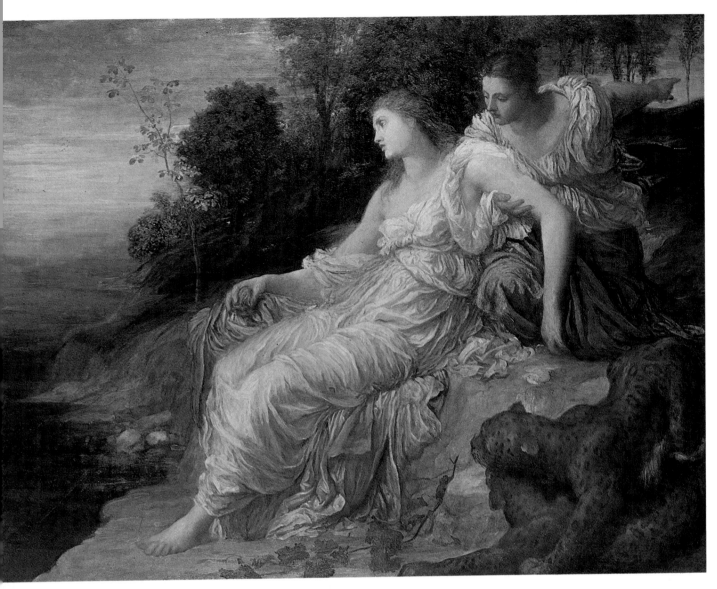

59. George Frederic Watts (1817–1904): *Ariadne in Naxos*. 1875.
Canvas, 75 × 94 cm. (29½ × 37 in.) City of London, Guildhall Art Gallery

visions whose intent, though now obscured, was to improve the age in which he lived.

From the twentieth-century point of view, Watts's most relevant achievement lay in the field of technique. From the 1870s onwards he made daring experiments with paint, first laying his colours out on blotting paper to extract the oil, and adding opaque glazes to his pictures, using more paint than he required and then scraping part of it off with scraps of paper. He experimented with the use of benzine as a vehicle for paint and would use anything that was at hand to paint with, be it the stump of a paintbrush, rag, paper or even his thumb. He eventually ordered specially ground colours from Winsor and Newton, which were sent to him in porcelain jars and were kept under water in order to prevent the scant amount of linseed oil in the colour from evaporating. His method has been described as his 'inspirational approach', as it depended essentially on constant experiment and a

search after unexpected effects. The result was that even the air in his paintings seems as if turned to paint. His paintings glow with suffused light due to the coagulated colour. It was a technique best suited to portraiture, because the personalities of his sitters pierce through the cloudy atmosphere and are enhanced by their nebulous surroundings. This technique, combined with his suggestive subject-matter and his ability to compress experience into a few forms, have led critics to relate Watts's style to French Symbolism.

In his literary subjects, Watts revealed an imaginative power that equalled that of the Pre-Raphaelites. His *Ariadne in Naxos* (Plate 59) was, he thought, 'perhaps the most complete picture I have painted'. Unlike Leighton's painting of the same subject, Watts heightens the psychological appeal by hinging the emotional drama on a moment of change. Ariadne, who has been abandoned by her lover Theseus on the island of Naxos, is soon to have her sorrow dispelled by Dionysus, whose arrival is indicated by the gesture of the attendant. Both subject-matter and style are indebted to Titian and, in the rippling draperies, to the example of the Elgin Marbles. Watts also uses drapery to heighten the emotion of the scene in his *Paolo and Francesca* (Plate 58), illustrating a passage in Dante's *Inferno*. Because of their adulterous love, the souls of Paolo and Francesca are condemned to be blown hither and thither endlessly by a howling wind, a movement successfully evoked by pose and drapery, whilst their pallid faces tell of their deathly state. Watts may have been familiar with Rossetti's treatment of this subject, but he would almost certainly have seen one of the versions of this scene by the Swiss artist Ary Scheffer and he was clearly indebted to it both for mood and pose.

The story of Paolo and Francesca parallels the Arthurian romance of Queen Guinevere's love for Lancelot, who had been sent to woo her on behalf of King Arthur. Dante and Malory's *Morte d'Arthur* remained the most popular literary sources for painters at this time. Henry Holiday's *Dante and Beatrice* (Plate 60), exhibited at the Grosvenor Gallery in 1883, when reproduced as a print rivalled even Millais' *Bubbles* in popularity. Tennyson, on the other hand, had ensured the continuing popularity of King Arthur by his reworking in his poems of the Arthurian legend and by creating the immensely popular figure of the Lady of Shalott. Confined to a tower, the lady is forbidden to look at the actual world except in the reflection of a mirror, but one day Sir Lancelot rides past, singing heedlessly to himself, and the lady is so captivated by his appearance, she leaves her loom and looks out of the window, bringing the curse of death upon herself.

For Tennyson the poem was a romance, the moral of which was, if anything, vague. But in the hands of Holman Hunt it became a sermon on the 'sinfulness of dereliction of duty', as he described it, and illustrated 'the failure of a human soul towards its accepted responsibility'. Hunt had contributed a drawing of this subject to the 1857 Moxon edition of Tennyson's poems, but in 1886 he picked up the subject again and produced a large and small version of this theme, both of which were not completed until 1905. Hunt chose to represent the dramatic moment when the spell under which the lady lives is broken:

Out flew the web and floated wide;
The mirror crack'd from side to side;
'The curse is come upon me', cried
 The Lady of Shalott.

Hunt brought to the large version of this subject (Plate 61) his detailed Pre-Raphaelite technique combined with an extraordinarily elaborate iconography which far exceeds that found in Tennyson's poem, and is expressed through the symbolic objects and decorations that fill the room, their static details offset by

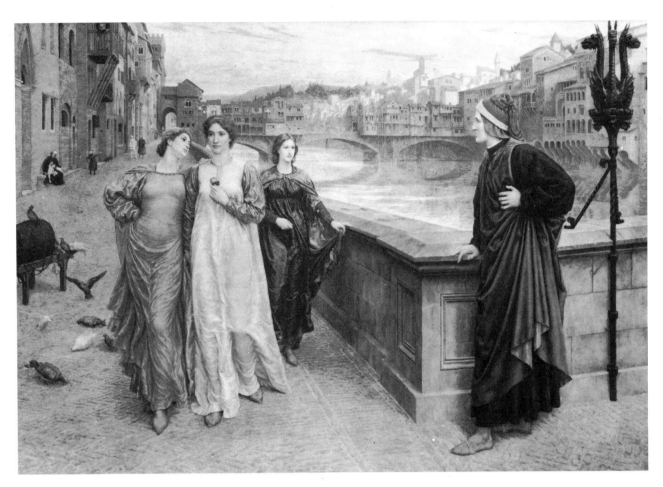

60. Henry Holiday (1839–1927): *Dante and Beatrice*. Exh. Grosvenor Gallery 1883.
Canvas, 142.2 × 203.2 cm. (56 × 80 in.) Liverpool, Walker Art Gallery

the flaming aureole of the lady's hair.

Renewed interest in medievalism during the 1880s was no doubt partly due to the retrospective exhibition of Millais' work held at the Grosvenor Gallery in 1886. Many of his early Pre-Raphaelite paintings had not been on public view for several years and their brilliance, both in conception and colour, made a fresh impact on a younger generation of artists. For J. W. Waterhouse the exhibition came as a revelation. After his training at the Royal Academy Schools, he had begun by adopting the classical genre subject-matter of Alma-Tadema and with it he achieved immediate success. But after seeing the Millais exhibition, he determined to adopt a Pre-Raphaelite approach, imitating not their detailed observation of nature, but their

complete, imaginative identification with the subject in hand. Aware, also, of the broader methods of painting resulting from the introduction of *pleinairisme* into England, he adopted a loose, descriptive brushwork, well suited in its speed to his convincing flair for narrative. Although his work reveals no clearly identifiable personality, his vivid imagination enabled him to paint Pre-Raphaelite subjects with a liveliness and gusto that made him a leading exponent of medieval romanticism up to and around the turn of the century. Occasionally his art suffers from harsh colour, slackness of line, a cloying sentimentality and from the oddness that results from representing ideal figures in a naturalistic style. But at his best, as in *Saint Cecilia* (Plate 63) of 1895, he transcends

73

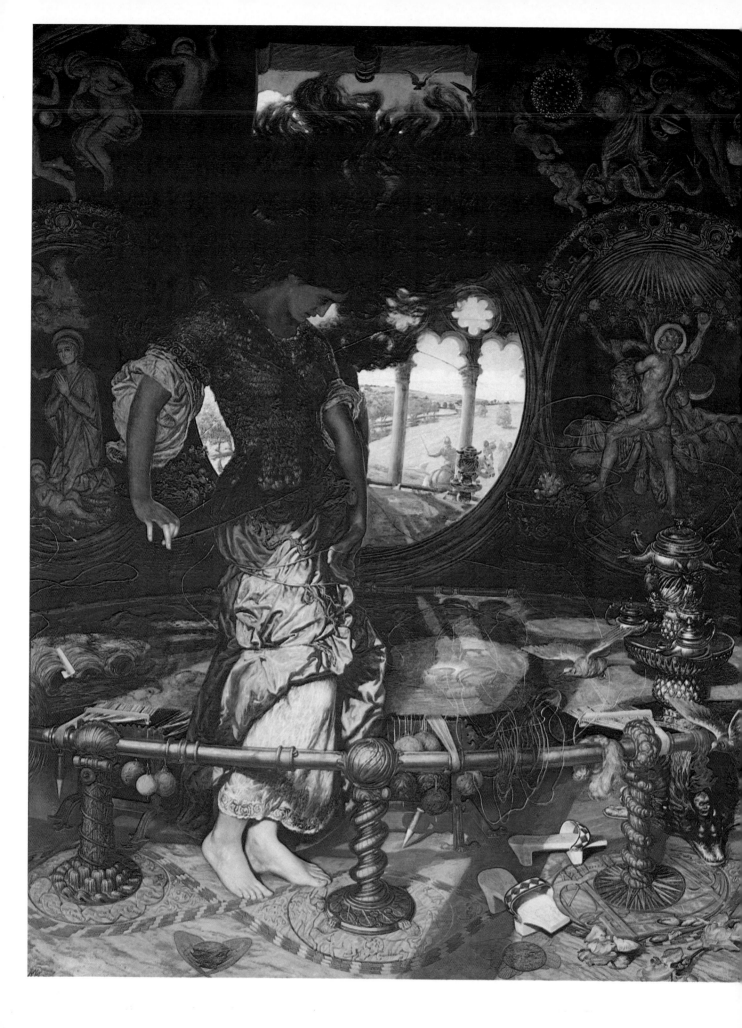

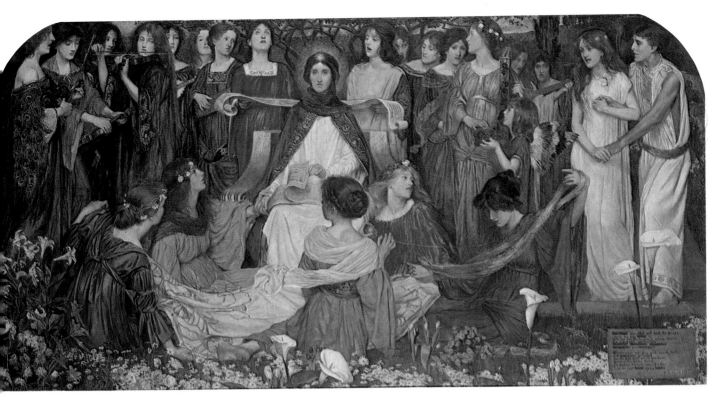

62. James Byam Shaw (1872–1919): *The Blessed Damozel*. 1895. Canvas, 94 × 180.4 cm. (37 × 71 in.) City of London, Guildhall Art Gallery

61. William Holman Hunt (1829–1919): *The Lady of Shalott*. 1905. Canvas, 188 × 144.7 cm. (74 × 57 in.) Hartford, Connecticut, Wadsworth Atheneum

63. John William Waterhouse (1849–1917): *Saint Cecilia*. 1895. Canvas, 123.2 × 199.4 cm. (48½ × 78½ in.) Private Collection. (Photograph courtesy of Maas Gallery)

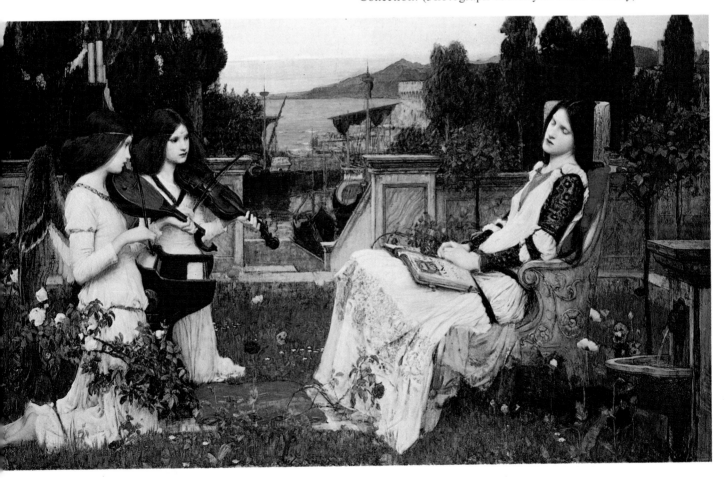

story-telling and evokes a dream-like setting, in which the glowing vermilions echo their way across the elaborate design.

James Byam Shaw's *The Blessed Damozel* (Plate 62) of 1895 is another instance of the late revival of Pre-Raphaelitism, both in its subject-matter, based on a poem by Rossetti, and in its claustrophobic use of a dense fabric of colour and texture that allows only the smallest glimpse through to the landscape behind. Elsewhere, Byam Shaw shared Waterhouse's more vigorous approach, as did other artists working in the nineties. In order to prolong the imaginative force of these classical and romantic dreams, the figures had to be animated with more spirited emotions than those found in Burne-Jones's graceful, but passive maidens. An extreme example is Herbert Draper's *Ulysses and the Sirens* (Plate 66), in which the skilled draughtsmanship and classical severity of Leighton is combined with Waterhouse's simpering female nudes. The sirens with their power of song lured sailors to steer their vessels on to the rocks. Forewarned of this, Ulysses had the ears of his sailors stopped up with melted wax. He left his own unstopped but, uncertain of his powers of resistance, he had himself lashed to the mast. When passing the island inhabited by the sirens he was so overcome by their song that he ordered the sailors to unbind him but, unable to hear, they did not obey, and the ship passed to safety.

By the 1890s Olympian and Arthurian ideals were being slowly undermined by new art forms, in particular Impressionism and Art Nouveau. Aubrey Beardsley, the draughtsman and illustrator who successfully caught the *fin-de-siècle* mood of decadence, gave a final vicious twist to the late Victorian dream. Although in 1891, at the beginning of his career, he had visited Burne-Jones and received encouragement from him, the following year he was commissioned to illustrate an edition of the *Morte d'Arthur*, and to Burne-Jones's horror he satirized and cruelly exaggerated the mannerisms of his mentor's art and the decorative style of Morris's Kelmscott Press (Plate 64). Thus the wilful compositions, the asymmetry, and the exaggerated elegance of Burne-Jones's designs are used to ridicule the movement that gave them inspiration. The chivalric ideal is displaced by a menacing sense of evil and decay.

Impressionism was also eroding the sacred Olympus, but from a different angle: the propagation of noble ideals was eschewed for the sake of recording the transient effects of nature. In 1886 the New English Art Club had been set up in opposition to the Royal Academy, to allow those artists to exhibit together who had trained in Paris or were in sympathy with *pleinairisme* (with painting out of doors). The paintings exhibited were less indebted to the Impressionism of Monet, Sisley, Renoir and Pissarro, than to the new realism found in the work of Bastien-Lepage. The result was often flat naturalism, lacking in underlying design. A temporary off-shoot of the New English Art Club was Whistler's group of London Impressionists, who believed that poetry and magic would be found not amongst gods and goddesses, but in the everyday life of London streets. Both styles were partly indebted to the example of French Impressionism, but it was not until 1905, when Durand-Ruel brought a large selection of French paintings to the Grafton Gallery in London, that this movement became widely understood and appreciated in England. The same year saw a large exhibition of Watts's art at Burlington House, the Whistler memorial exhibition at the New Gallery and a Victorian

64. Aubrey Beardsley (1872–98): *Arthur Glimpsing the Questing Beast.* Illustration to Malory's *Morte d'Arthur*, 1893–4

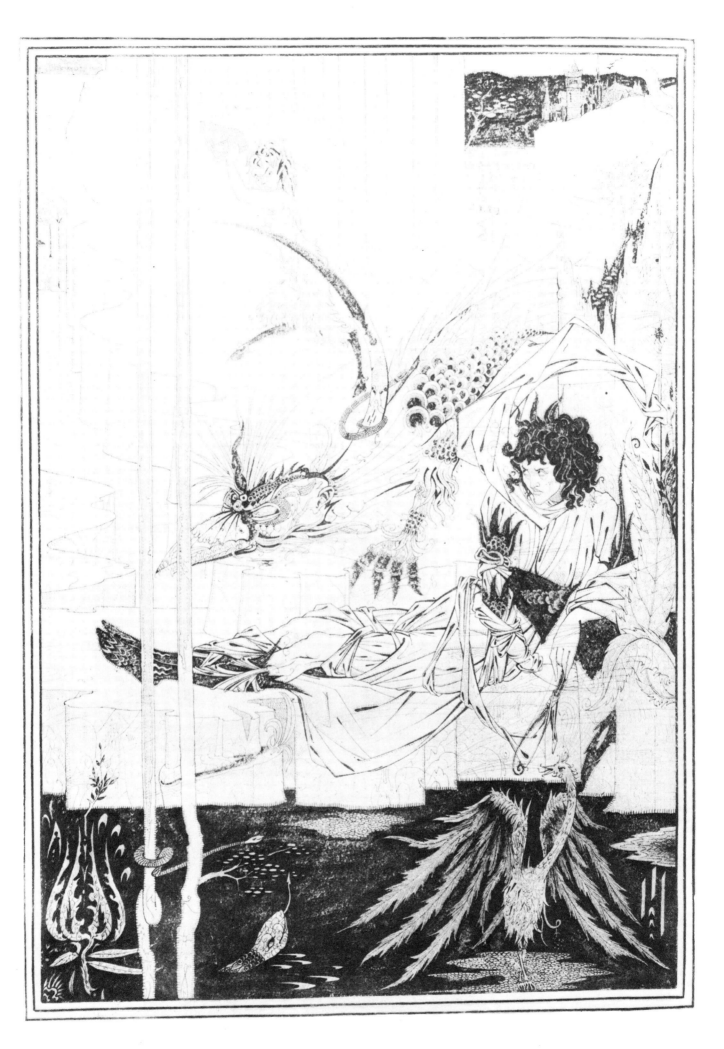

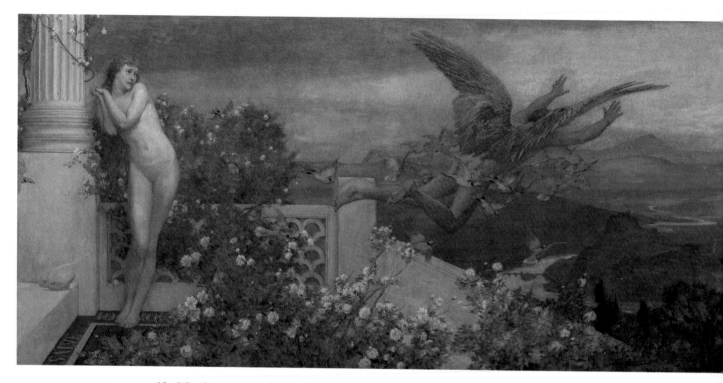

65. Matthew Ridley Corbett (1850–1902): *A Loving Psyche Loses Sight of Love*. 1900.
Canvas, 99 × 208.3 cm. (39 × 82 in.) London Borough of Southwark, South London Art Gallery

exhibition at Whitechapel, in which a section was devoted to the Pre-Raphaelites. The latter's influence was still prevalent enough to allow comparison in the press of their aesthetic with that of the French Impressionists. It could, indeed, be argued that Pre-Raphaelitism never died, but merely went to ground and that faint reverberations of it are still to be found in the annual Royal Academy summer exhibitions. Well into the second and third decade of this century, work was being produced in the Pre-Raphaelite tradition, although the visions gradually paled, becoming increasingly decorative and lacking in conviction. Reginald Frampton's *Saint Cecilia* (Plate 67) of 1917 is an example of a decorative echo of Pre-Raphaelitism, also produced by R. Anning Bell and Cayley Robinson, the latter enjoying a considerable vogue in the 1920s.

Late Victorian dreams are a strange mixture of individualism and academism, lifted on to an ideal plane. They compel our admiration because of their magnificence, their rhetoric and manifest conviction as well as for their aesthetic content. Matthew Ridley Corbett's *A Loving Psyche Loses Sight of Love* (Plate 65), which was exhibited at the Academy in 1900, is a fine, if late, example of the skill and the imagination it took to make a late Victorian dream magnificent. The effect is enriched by Corbett's individual sense of colour, the subtlety of which owes much to his landscape studies made in the company of the Italian painter, Giovanni Costa. But our enjoyment of these dreams is troubled by awareness of the divorce between these inner visions and the outer reality, by our knowledge that, while Burne-Jones at the end of his life dreamt of the timeless sleep of Arthur in Avalon, the external world was being subjected to con-

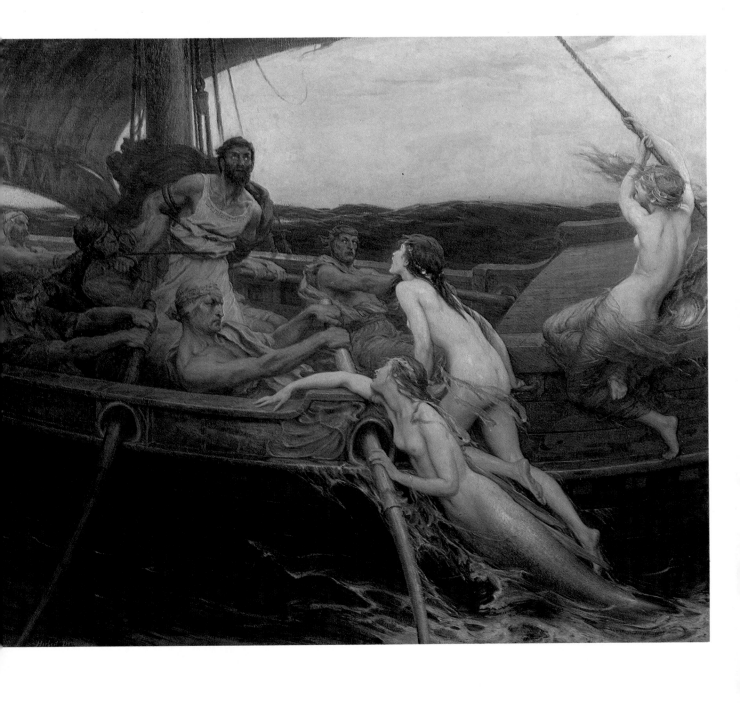

66. Herbert Draper (1864–1920): *Ulysses and the Sirens*. Exh. 1909.
Canvas, 176.8 × 213.3 cm. (69⅝ × 84 in.) Hull, Ferens Art Gallery

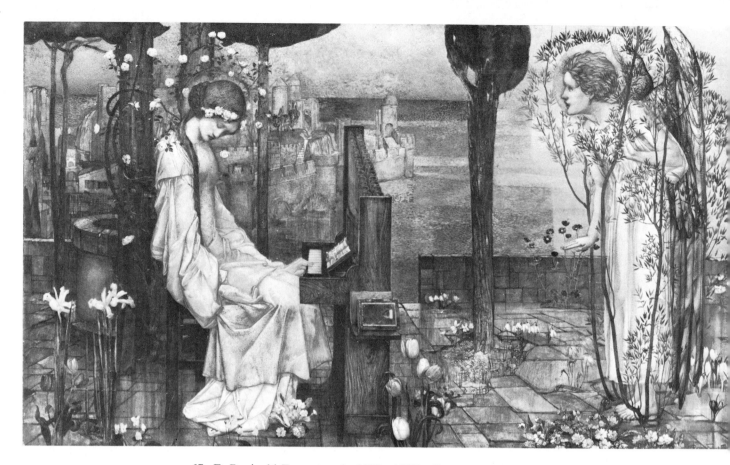

67. E. Reginald Frampton (*c.* 1850s–1923): *Saint Cecilia*. Exh. R.A. 1917.
Gouache, 71.1 × 122 cm. (28 × 48 in.) Private Collection, Los Angeles. (Photograph courtesy of Julian Hartnoll)

stantly accelerated change; the District Railway had reached Fulham, where Burne-Jones lived, and in its tracks came the speculative builder. Ironically Tennyson, whose poems did much to transport Victorian artists into an unreal world, left a clear warning in his poem 'The Palace of Art' of the danger of the artist's retreat from the world in which he lives. His conclusion makes an apt comment on the artistic achievement of the period as a whole:

> Yet pull not down my palace towers, that are
> So lightly, beautifully built:
> Perchance I may return with others there
> When I have purged my guilt.

68. Sir Edward Burne-Jones (1833–98): *The Homes of England*. Pen and ink.
Illustration to *Some Eminent Victorians*, by J. Comyns Carr. Present whereabouts unknown.

80